GOINGDIGITAL>>
wedding and portrait photography

RotoVision

A Rotovision Book

Published and distributed by RotoVision SA
Route Suisse 9
CH-1295 Mies
Switzerland

RotoVision SA, Sales, Production & Editorial Office
Sheridan House, 112/116A Western Road
Hove, East Sussex, BN3 1DD, UK
T +44 (0)1273 72 72 68
F +44 (0)1273 72 72 69
ISDN +44 (0)1273 73 40 46
Email sales@rotovision.com
www.rotovision.com

10 9 8 7 6 5 4 3 2 1

ISBN 2-88046-6938

Designed by Design Revolution

Originated by Hong Kong Scanner Arts
Printed and bound in China by Midas Printing

GOINGDIGITAL>>

wedding and portrait photography

JOËL LACEY & JOHN HENSHALL

CONTENTS

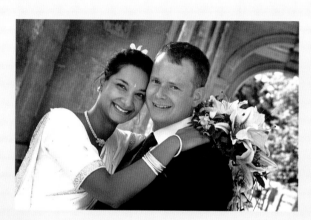

INTRODUCTION

THE RECENT ADVENT OF DIGITAL PHOTOGRAPHY HAS CAUSED ONE OF THE BIGGEST SHAKE-UPS EVER SEEN IN THE LONG AND INNOVATIVE HISTORY OF CAPTURING LIGHT FROM AN OBJECT TO CREATE A LASTING IMAGE.

Not since the arrival of colour photography have photographers been so divided as they are over digital imaging, although most professional photographers are prepared to judge this new technology on its merits.

Before we look in detail at what digital imaging is, let's set out the four pathways of photography. There are four because there are two ways to take pictures – analogue and digital – and two ways in which they can be output – also analogue and digital. This gives four possible permutations:

1 Analogue in Analogue out
2 Digital in Analogue out
3 Analogue in Digital out
4 Digital in Digital out

Three of these four pathways contain digital imaging, which shows that 'going digital' offers several ways to use the technology to provide your customers with the image they want in a way that is both convenient and profitable for you. Let's put the four pathways into a more explicit format:

1 Film in Silver Halide prints out
2 Digital input Silver Halide prints out
3 Film in Digital output
4 Digital input Digital output

Now, you may think that there is not a great deal of difference between these two lists. However, digital output (much like digital imaging) does not offer just one option, but embraces many. We'll be looking at these options, both in the abstract and in practical ways, throughout this book, in the case studies of working photographers who use varied approaches to the creation of digital images.

There is no doubt that there is a lot to learn about digital imaging, and no serious photographer would claim to know everything. However, you can easily begin by finding out what you need to know and prioritise the aspects that are relevant to your business.

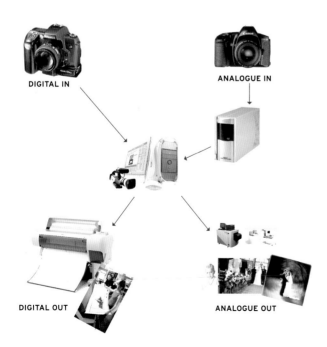

DIGITAL IN

ANALOGUE IN

DIGITAL OUT

ANALOGUE OUT

The process
There are four possible methods of applying digital imaging to a wedding or portrait business. Even the film-to-photographic-paper route can have a digital mid-point to allow correction and manipulation of images.

01 As well as manipulation of individual images, digital imaging allows the combination of different shots to form a collage of key moments during a wedding, as in this three-shot combination by Stuart Bebb.

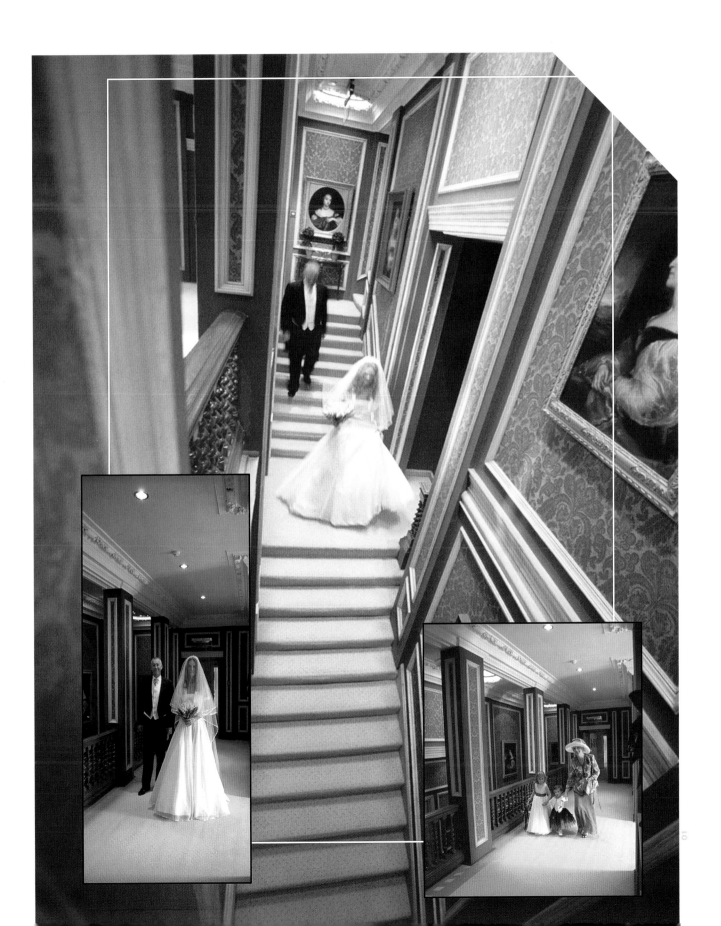

From chemicals to numbers

WHAT'S THE DIFFERENCE BETWEEN SILVER HALIDE AND DIGITAL IMAGING?

As we have discussed, digital and analogue techniques can be combined in different ways to produce images, and some methods will suit your business and your personal style better than others. But there is an essential difference between silver halide and digital imaging. The silver halide technique makes an analogue record of an image by using chemical reactions, while digital imaging records an image as a collection of digits.

From this one difference, a great number of possibilities and opportunities emerge. Learning about digital imaging begins with a basic understanding of how the technology works, but the real learning takes place when these possibilities and opportunities begin to be explored. It's just like a car; the most interesting part is learning about the different places that it can take you, but it's also a good idea to know something about the technology that's turning the wheels.

The next few pages are designed to help you understand the technology inside the three main forms of digital imaging: digital capture by using a digital camera, digital capture by using a scanner, and digital manipulation and output.

CANON EOS D30

CANON EOS 1D

FUJI FINEPIX S1

KODAK DCS760

CANON EOS D30

NIKON D1X

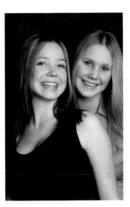
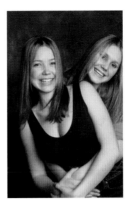
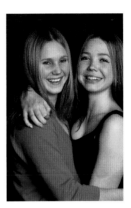

CANON EOS D30

CANON EOS 1D

FUJI FINEPIX S1

KODAK DCS760

NIKON D1X

CANON EOS D30
A relatively inexpensive model, which may lack the rugged build of more expensive models, but, as the pictures show, in resolution terms is more than capable of capturing sharp images.

CANON EOS 1D
A model built to withstand the rough and tumble of photojournalism. Its 4 megapixel chip does not deliver noticeably more or less detail than a 3 or a 6 megapixel sensor.

FUJI FINEPIX S1
This combination of a Nikon body and Fuji digital sensor uses a series of octagonal (as opposed to the usual square) pixels to capture the image. Top resolution is over 6 million pixels.

KODAK DCS760
Built like a tank, and using a different form of colour processing to the other digital SLRs, this Kodak model is the most expensive in this group.

NIKON D1X
This Nikon uses interpolation to output an image of just over 6 million pixels per shot.

DIGITAL CAMERAS

An image is captured in a digital camera by light falling onto a mosaic of light-sensitive sensors contained in a charge-coupled device (CCD). The sensors convert the light into a digital form that records colour and intensity. The more sensors that the CCD contains, the more picture elements (pixels) are used to form the image. The number of sensors on a CCD is measured in millions (megapixels) and the minimum working professional camera is a single-lens reflex (SLR) with 4 megapixels. However, as the CCD is normally smaller than a 24x36mm 35mm film frame, the focal length of a lens when fitted to a digital camera is 1.4x-1.6x greater than a lens with the same focal length fitted to a film camera. A 20mm lens when fitted to a digital camera gives the same angular coverage as would a 28-32mm lens on a film camera.

In contrast to film cameras, digital cameras store their digitised images on memory cards. The number of images that a card can store depends on the size of the card, the quality of the exposure that you select, and the amount of detail in each individual image.

An important difference when you are taking pictures with a digital camera is that you can very quickly view the image you have just taken. When you take pictures with film SLRs, the mirror pops up and the viewfinder goes black. With digital, you can check exposure, flash, composition and, to a degree, sharpness, within a couple of seconds of the picture being taken.

35MM FILM CAMERA

CANON EOS D30

CANON EOS 1D

FUJI FINEPIX S1

KODAK DCS760

NIKON D1X

FIELDS OF VIEW
As the size of the sensor chips in digital cameras varies from model to model, a given focal length of lens on a 35mm camera will have a different focal length, and also angular coverage, when mounted on a digital SLR. These six shots show the respective fields of view with a single focal length of lens on 35mm and the five digital SLR cameras shown on this page.

DIGITAL SCANNING

This is a way of approaching digital imaging if you are uncertain about using the new technology to capture an original digital image. It is also the best method of combining older images with newer ones by converting them both into digital forms.

Scanning can be done either from film (slide or negative) or from a print. The former usually contains more detail, but the latter is a lot quicker and simpler. You may already have had your pictures scanned without even knowing it. Some of the newer printing machines scan in an image, rather than projecting through it, and then print it digitally onto traditional colour silver halide paper. We'll look at scanning in more detail a little later in the book.

DIGITAL MANIPULATION AND OUTPUT

These two processes usefully highlight the differences between film and digital photography.

With film-based photography, manipulation and output of the image make up a single process. If you use a lab to create effects, such as a vignette, a dodge or a burn, the result of this manipulation only becomes apparent after the image has been processed, washed and dried down. It is only then that the success of any applied effects can be accurately assessed.

In digital imaging, manipulation takes place before the image is printed – and, as far as digital manipulation is concerned, there is no limit to what you can do. This is both a positive thing and a negative one. On the positive side, you can remove extraneous detail in the background, combine separate group shots, clean teeth, open eyes and generally make a slightly less-than-perfect picture, perfect. On the negative side, you could spend all your waking hours on a single picture and never be finished. However, one of the most positive aspects of digital manipulation when compared to traditional printing is that you can see the results on-screen as you carry them out, and adjust them as you need until you are ready to print the results.

01 One of the greatest benefits of digital imaging is that it allows the photographer to make minor corrections in seconds that would take hours in traditional imaging. In this Eliot Khuner shot, the possibly distracting light seen over the bride's shoulder (picture **02**) has been removed and a contrast adjustment made to enhance the skin tones and the appearance of the pearls.

03 Creative manipulation on the scale of this image by Helen Yancy may take hours with a digital imaging system, but they would be nearly impossible by any traditional retouching method... except the very traditional one of painting it from scratch. Even then, it would be extraordinarily difficult to get the mix of realism and fantasy achieved by the combination of a digital photo and a creative digital imaging program (in this case Corel® Painter™) in the hands of an expert.

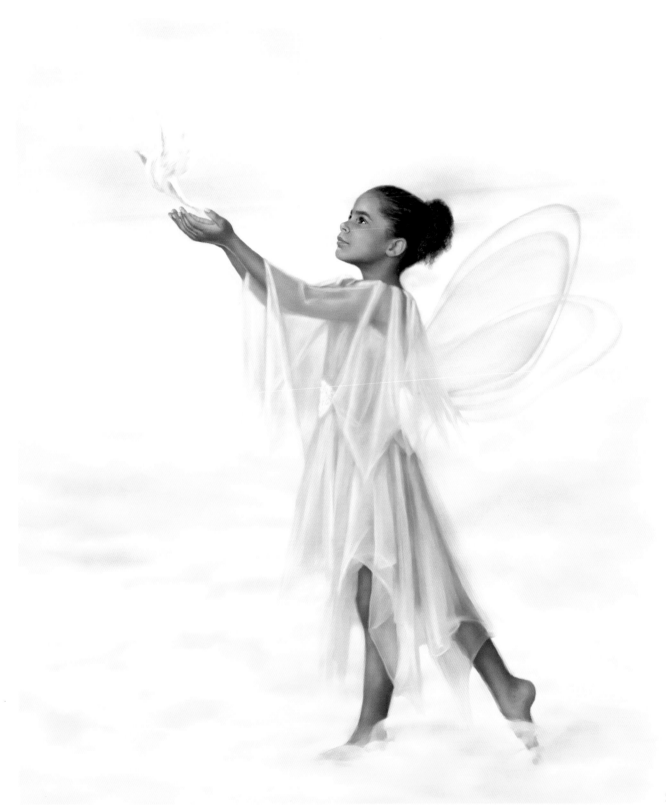

What is digital imaging?

SIMPLY PUT, DIGITAL IMAGING MEANS THAT PICTURES ARE
HELD IN THE FORM OF 0s AND 1s.

An image is made up of a mosaic of squares – pixels – digitally encoded in 0s and 1s to form a grid. Each pixel is a description of the colour and brightness of that tiny square. The number of pixels in each image is known as the image's resolution. It is often described in one of three ways: the number of columns multiplied by the number of rows of pixels, for example, 2560x1920 pixels; the total number of pixels in an image, for example, 4.9 megapixels or 4,915,200 pixels; or the amount of memory a digital image occupies, for example, 14.1Mb. A 0 or a 1 is known as a binary digit, or a bit, which combine together into groups of 8 digits to make a byte. Each image pixel is described in terms of 24 bits.

DIFFERENT COMBINATIONS

As we are counting in binary, these 24-bit pixels each contain a number between 0 and 16,777,215. There are 16,777,216 different combinations because that is the value of 2 raised to the power of 24. That power of 24 is derived from the fact that digital imaging describes images in terms of their three primary colours: red,

green and blue. Each of these colours can be described by one of 256 different shades, so we end up with 256x256x256=16,777,216 different possible combinations in the three possible ways of describing a file. We can now compare these three descriptions for a single image and see how they can be used in combination. Our 14.1Mb file contains 4,915,200 pixels, each of which can be described by a number between 0 and 16,777,215. Zero would be a pure black pixel, and 16,777,215 would be a pure white pixel.

If your head is spinning as a result of trying to take on board the complexity of the numbers mentioned so far, remember that a digital camera that captures an image of this size has to record all this information and then has to allow you to take the next shot in the shortest possible time. You might also begin to understand why many of the photographers mentioned in the case studies in this book talk of the amount of time that digital imaging takes. Given that each change you make to a picture causes a complex series of mathematical changes to 4,915,200 24-digit numbers, you can see why even the latest and fastest pieces of technology cannot perform every task instantly.

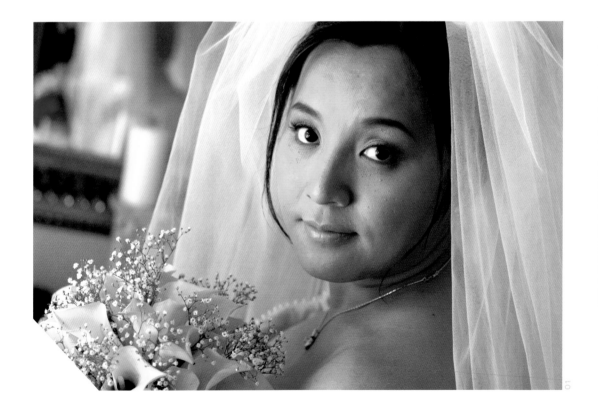

01 Low-light shooting with digital cameras is often easier than with film cameras. Just like film, though, the higher the sensitivity the chip is set at, the more likely it is you will see the component parts of the image. These are not grains formed by clumps of dyes, but rather individual pixels that stand out. Ordinarily you will never see a pixel unless your image has been enlarged beyond its recommended physical size at your chosen printing resolution. (Image by Eliot Khuner.)

RESOLUTION

Resolution is an issue that confuses a lot of people: in addition to the three ways we've already seen of describing an image, there is a fourth in common usage, and in many ways it is the most meaningful. Here we are talking about the physical dimensions of an image when it is printed. So someone might refer to a 12x9-inch image. However, without some additional resolution figure, this is meaningless. A 12x9-inch image with an image resolution of 1 pixel per inch would only contain a total of 108 pixels. An image of the same physical size with 213.333 pixels per inch would contain 12x213.33333x9x213.333 pixels, i.e. 4,915,200. So our example digital image can be said to have a physical size of 12x9 inches at 213.33333 pixels per inch (ppi). This is not the same as dots per inch (dpi), and we will explain why they are different when we come to talk about printing.

BELOW
The same shot as that shown on the left at the same physical size, but this time with an image resolution of 300ppi. The component pixels have disappeared, and what you see is the image as taken by Eliot Khuner.

ABOVE
This sectional enlargement of an image has a resolution of 10 pixels per inch. As you can clearly see, the component parts of the picture have become blocky, and a sense of what is in the image can only really be gained by viewing the image from a few metres away.

DIGITAL INPUT USING A SCANNER

Scanning can be broken down into two forms: reflective (from prints) and transmissive (from negatives or transparencies). Unless you are going to use other people's prints to incorporate into an album, we'll ignore reflective scanning for the purposes of this book.

Transmissive scanning

Transmissive scanning is where a high-resolution sensor passes on one side of a film, while a bright light source of a known colour temperature is passed along the other side of the film. Let's take the example of a negative that we want to scan on a scanner with a maximum resolution of 4000 pixels per inch. Our 35mm film frame – and let's assume it is exactly 24mmx36mm – will produce an image with 3780 pixels on the short side by 5669 pixels on the longer side.

Now let's assume we will want to print it at a physical size of 12x8 inches (the same 3:2 aspect ratio as the negative). What kind of pixels per inch figure would that give us? If we divide 5669 pixels by 12 we get a rounded figure of 472ppi. Similarly, 3780 divided by 8 also gives us 472 (rounded) because the pixels per inch figure is always the same in both directions. At that resolution, we could print as big as 20x16 inches.

Time, dust and tweaks

The time it takes to scan is usually the single longest process you'll carry out. So, if you can, choose a scanner with batch capability that can scan a complete film of images without any further intervention. In addition, dust can be a major problem when scanning, so look for a scanner that has a form of dust removal software built into the scanning process.

Although the business of scanning is an entirely automatic operation once started, you will need to check each scan closely to see if the image needs any tweaking – especially where the exposure was not perfect.

02 This test chart was generated entirely digitally in Photoshop® and shows how the pure 'system' colours of RGB would be represented on-screen.

03 The same image was output to photographic paper and then scanned back in to the computer. A number of colour changes have occurred – some at the printing stage (where the photographic paper is unable to completely match the full gamut of colours) and some at the scanning stage. It is worth remembering with scanning that what you see on the original is not always what you get after the scanning stage.

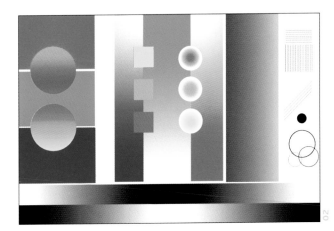

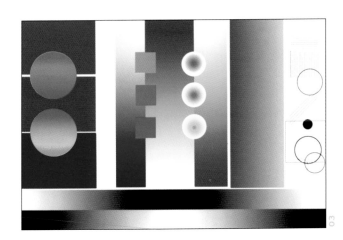

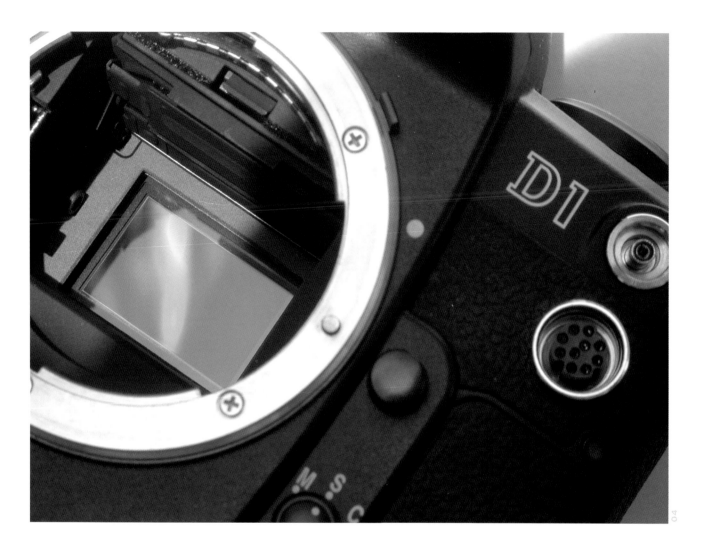

04 The heart of the digital camera is the imaging chip. In this case it is the CCD of the Nikon D1 SLR. It sits at the focal plane where the film would be in a traditional SLR.

DIGITAL INPUT USING A CAMERA

Digital cameras work by converting the light falling onto the CCD into a voltage, which is proportional to the brightness of the light combined with the duration of exposure. This voltage is converted to a number, and that number represents the brightness of that pixel. The sensing elements are, in themselves, colour blind, so the sensors are covered with filters that either transmit only primary colours (red, green and blue) or secondary colours (cyan, magenta and yellow) to the sensors underneath. In the former case, the sensors are laid out in a grid with one line made up of alternating red and green filters and the next line made up of alternating green and blue filters.

Interpolation

Some cameras contain software that uses 'interpolation' to increase the pixel size of an image. New pixels are created – interpolated into the existing image – by making calculations based on the colours of the surrounding pixels.

05 The unmistakable RGB pattern of the CCD imaging sensor filters. A digital camera's sensors are colour blind, and can only deliver colours by being filtered. Details of the colours captured by each CCD element are compared with those adjacent to it, and an averaged colour value applied to it.

06 Digital images are formed from two sets of actions: the splitting of scenes into individual pixels' light values and their colour values. These are converted into digital form (i.e. 0s and 1s), which can be read, manipulated and saved by the computer and its software.

07 The end product of digital imaging is normally a print. Here we see a Fuji Pictrostat printer with a batch of images printed by Charles Green's studio.

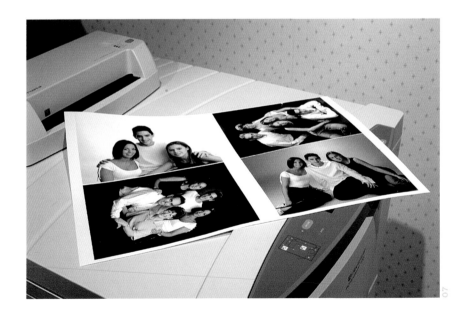

DIGITAL DOUBTS

One area that causes problems for people trying to understand digital imaging is the difference between pixels per inch and dots per inch. Here, we attempt to remove this confusion.

Pixels per inch

Camera resolution is a static number that is measured by the number of sensors in a camera's CCD, for example, 1.8 megapixels. Image resolution, however, is measured in pixels per inch (ppi) and changes with the size of the printed photograph. For example, imagine that a picture has been taken with a digital camera that has a resolution of 1.8 megapixels, and that the picture has been printed at 300 pixels per inch on a 4x5-inch sheet of rubber. This produces 1200 pixels on the shorter side (300x4) and 1500 pixels on the longer side (300x5). Multiplying 1200 pixels by 1500 pixels produces 1.8 megapixels.

Now imagine the sheet of rubber being stretched to twice its size in both directions to produce an 8x10-inch picture. The stretching process also increases the size of each of those 1.8 million pixels. If you continue to stretch the rubber sheet, eventually each separate pixel will be large enough to see and the image will show signs of jaggedness. A second effect of stretching the image to twice its size is that instead of 300 pixels occupying each inch of the image, there are now only 150 pixels per inch. However, there is still a total of 1.8 megapixels making up the image and there are still 1200 pixels on the shorter side and 1500 on the longer.

Smaller-sized prints from a given image have smaller pixels and have more of them to the inch (a higher ppi figure). Larger prints from the same image have larger pixels and have fewer of them to the inch (a lower ppi count).

Dots per inch

An inkjet printer reproduces an image's pixels by squirting round dots of ink onto the paper. The number of dots along an inch of paper is the printer's resolution and is measured in dots per inch (dpi). Most photo-quality printers have different dpi resolution settings to allow optimal output when using different types of paper and ink. However, using a high dpi setting cannot improve the image quality because only more pixels in the image can do that. In the example of the picture on the rubber sheet, the pixels enlarge as the picture size is increased and a high dpi setting on your printer may just make each pixel more apparent.

If you input a photo size of 8x10 inches and your program tells you that it has 150 pixels per inch, you can't just increase that quantity to, say, 300ppi in an image editor and expect to retain the 8x10 format. The dimensions of your picture will automatically decrease, which is the program's response to the fact that there aren't sufficient pixels available to be lined up at 300 per inch while retaining the previous size.

08 The least expensive way to print images in a studio context is an inkjet printer. These come in a range of prices. Epson's 2000P is a professional printer used for proofing.

09 Dye-sublimation printers produce an analogue-looking, continuous-toned image. The longevity of the print (as it is laminated) is said to exceed that of conventional photos.

KEITH THOMPSON
'With digital imaging I can relax and sleep again'

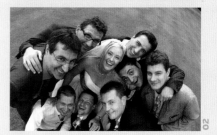

'Did the shutter work? Did the flash sync? Did the film wind on OK? Will the lab ruin my film? All these dreads became history when I went digital', says Keith Thompson, one of the world's most successful wedding photographers, 'with digital imaging I can relax and sleep again'. Not only could the pictures be lost but Keith Thompson's reputation could also be at risk. Now, thanks to digital, Keith is much more relaxed and confident.

Keith's first venture into digital capture was in 2000. In that same year he achieved the unique double of winning both the Fuji and Kodak Wedding Photographer of the Year awards. He has won the Fuji Wedding Photographer of the Year Award no less than eight times in ten years – in fact, he has probably won more awards than any other wedding photographer. His style encompasses contemporary, informal, semi-formal and reportage. He has always been a brave photographer, constantly looking for new ideas to stimulate his creativity and bring in more business, and had been using a Nikon CoolPix 900 consumer digital camera for candid photographs. He found that the immediacy of results created a new interest among clients, who wanted prints immediately, on location.

IMMEDIATE FEEDBACK
Keith's move to digital cameras for the main wedding photography was not without trepidation. Suppose the technology should fail? A wedding is a

one-off event, which is impossible to re-stage if something goes wrong. But not only did the technology work, it gave Keith immediate feedback about the success of shots. He found this both relaxing and inspiring. Added to this were the advantages of digital retouching and the creative possibilities of digital manipulation. There was no turning back. Keith's future was undoubtedly digital.

CUTTING COSTS
The biggest problem Keith faced was the higher cost of digital printing. Eventually, by shopping around, he found that he could get 15x10cm (6x4-inch) prints on-line for 15 pence and this made all the difference. He now burns his images to CD-ROM and has them proofed by the UK's largest high street photo-store chain, Jessops. Larger prints are made, also on conventional photographic paper, using professional laboratories such as Loxley Colour in Glasgow.

The first digital camera that Keith used was the Kodak DCS520 – the Canon EOS-bodied version of Kodak's two

megapixel (1152 x 1728) sensor professional camera. Since Keith was a Canon EOS user in his film days and shoots weddings in a reportage style, the DCS520 suited him well.

MAKING AN IMPACT
Making and showing prints on location at Keith's early digital weddings had an immediate success. At the reception, the bride and groom were presented with a framed print – signed by all the guests. The reaction was incredible. Guests were able to see their group shots on the back of the camera immediately, generating extra demand for print sales.

Today, Keith has graduated from the Kodak DCS520, through the Nikon D1X to the Fuji FinePix S1 camera, which he prefers for its lightweight, good colour and the speedy service he receives from Fuji when necessary.

01 On this shot Keith applied a one-inch black border and then picked the colour from the wood of the bridge to make a keyline. Boosted contrast and saturation were used to give a 'false feeling'.

02 For this fisheye shot of a wedding party, grass was 'cloned' over distracting background detail.

03 This colour image was desaturated; then, with Photoshop's History brush, the colour was painted back into specific areas.

04 Keith enhanced this dancing shot with Radial Blur (Spin) in Photoshop. He changed the colour mode to LAB Color, then moved the image to blue before returning the image to RGB mode.

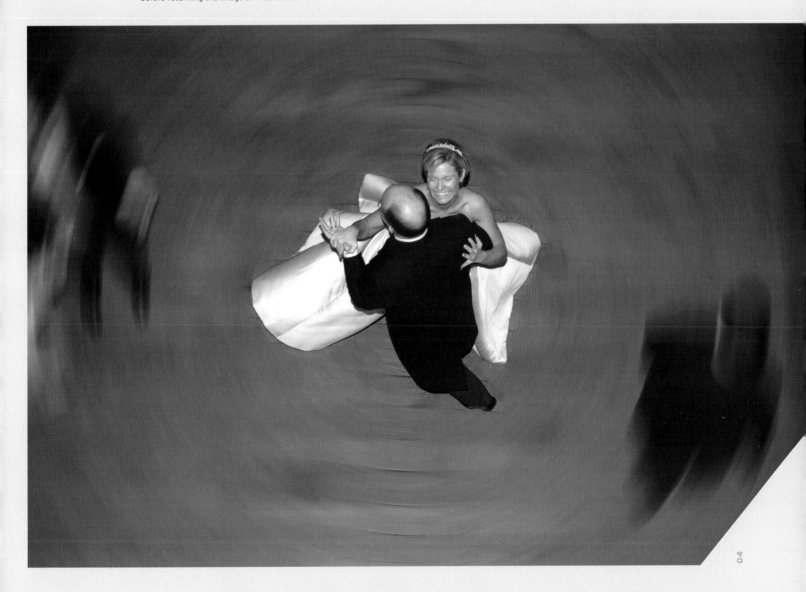

04

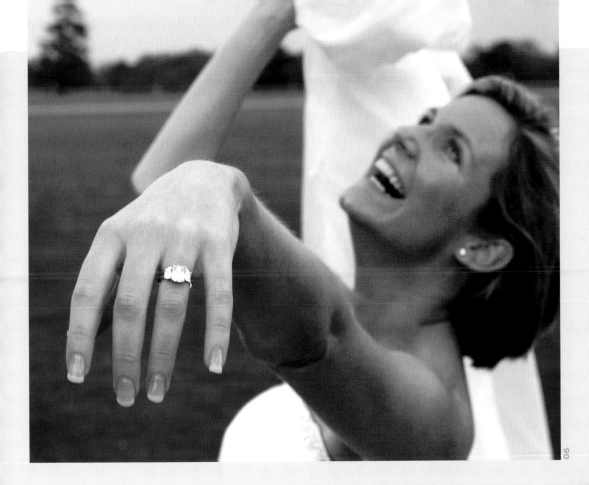

05 This shot, captured digitally, shows the clarity of the image possible with the Fuji S1 and Tokina 28-80mm.

06 LAB Color mode was used to enhance this shot of a bride showing off her ring and her wrap.

07 This is a pretty standard shot of a Christmas wedding, but the sensitivity of the digital camera meant that Keith could shoot at ISO 1600 handheld without flash. This could not have been done on a 'blad.

08 This fisheye shot was taken from a step-ladder. All the guests were asked to pull faces and (except the bride!) were either 'Liquified' or had Free Transform applied to grow or shrink their facial features.

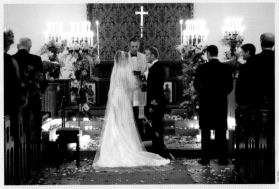

CHARLES GREEN
'Digital imaging has rekindled my excitement for photography'

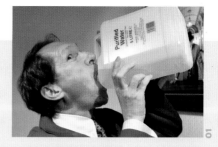

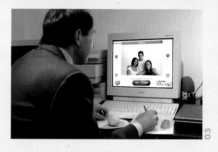

Charles Green is not a photographer who does things by halves. He seems to thrive on adrenaline, and is never afraid to put his reputation on the line. In 1992 he became the first photographer to produce a wedding album made up entirely of electronic pictures. He was the first portrait photographer in the UK to have a digital imaging facility. He was also the first to win Kodak Gold Awards with digitally manipulated images – something that caused a huge outcry and led to accusations of cheating. Since then he has been keeping a close eye on digital imaging, waiting for the time when digital technology would give him definite advantages.

Only three weeks before our meeting, Charles took the plunge and abandoned silver halide completely. The catalyst was the departure of his long-serving lab manager. Should he recruit and train a replacement? The prospect seemed quite daunting.

For nine years, one of Charles' main jobs has been the photographing of investiture recipients at Buckingham Palace, though he is reluctant even to mention this. He uses a team of six photographers and, since the beginning, has used Hasselblads with 24-exposure backs. But just one session of having to process the large number of 220-size rolls of film on his own convinced him that now was the time to close his lab, sell his Hasselblads (except his treasured gold one) and go digital.

FREEING THE IMAGINATION
Charles is clearly remotivated by his digital conversion. 'Digital imaging has rekindled my excitement for photography – I haven't been so excited since I got my first Meccano set. Going totally digital is the best thing since photography began. I've never really been happy with any 'wet' photography. When it's finished, you notice some small thing – a hair across the eye, a tie not straight – which you could retouch on the print with pencils, crayons or dyes but it's very skilled work, time-consuming and expensive. Today, if someone says, "I look a little fat", I can take something off their waist. Everything can be done in the computer. You are only limited by your own imagination.'

Charles used to employ a retoucher, but now he is his own retoucher. He lightens the whites of the eye a little and puts a small half-moon of colour into the pupil of every eye on the opposite side to the catchlight. The effect is stunning, making the eyes look three-dimensional.

SOFTWARE MODIFICATIONS
Charles needed more than digital cameras; he needed software to speed up the pre-print processing, and fast printers. He'd already decided against buying a digital photographic printer which uses RA4. 'They're the best part of £100,000 – if I had that kind of money spare I'd rather retire!'

'I looked at A4 heat-transfer (dye-sublimation) printers, but they would only print one 8x6 at a time. Then I discovered the Fuji Pictrography 4000 at Photokina. It costs about £15,000 and will print four 8x6 prints imposed on a single sheet of oversized A3 paper in little over a minute. Fuji didn't even realise that this effectively made it four times faster than dye-sub!'

He could have imposed the images in Photoshop, but this is a rather slow process, so Fuji modified its in-store Photo Kiosk software for Charles as a stop-gap, until its Pictrography software is modified to incorporate his 'dream' requirements.

01 The only chemical the Pictrography needs is a little purified water each day. 'It's unbelievable – as though it's on a diet', says Charles. 'In fact it's so environmentally friendly I can actually drink the chemicals!' he says as he takes a spoof swig.

02 A closer look at the oversized A3 print, sitting on top of the Pictrography 4000 printer. All that is required now is trimming.

03 Charles Green at the workstation, using the specially modified Photo Kiosk software to speed output to the printer. Charles enjoys the time spent at the workstation experimenting and learning new techniques. It stimulates his creativity and enables him to add special touches to perfect every shot with a minimum of effort.

04 It was during a trip to the US that Charles' love affair with the Fuji S1 Pro began. This picture of High Noon at Antelope Canyon was taken on that trip. It scored 85 – Silver – in the BIPP International Photographic Awards 2001.

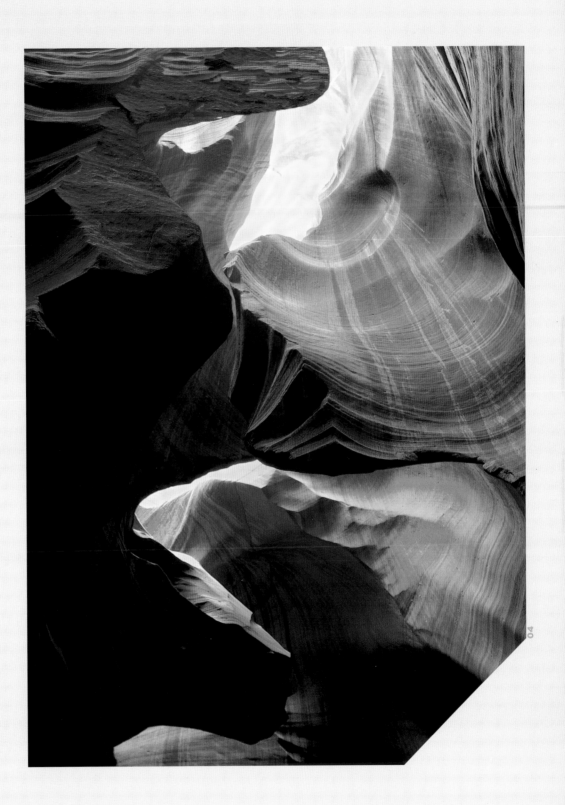

FINDING THE CAMERA

On the S1 camera, he says, 'When I saw the S1 I loved it and bought one. It was my first digital camera. It's made me so excited about photography again.' He took the S1 on a trip to the US. He also took a Mamiya 7, three lenses, tripod and exposure meter, but never used them once. 'On that trip the S1 worked perfectly for 1600 shots in all weathers – from snow at sunrise at Grand Canyon to the heat of the desert. It's sure not a flimsy camera.' This convinced him to buy six more S1s.

'With the S1, I don't have to think about which film to load, I just set the speed and colour temperature I need.'

Now Charles is going to change his whole shop window and put in a poster proclaiming, 'New Digital Studio – portraits while you wait'. He's going to put his prices up for that. 'The whole world has changed', says Charles. 'The internet generation expects it now. It's a great selling point. If you don't do it, people think you're old-fashioned or lazy.'

Neither of which you could ever say about Charles Green.

05 With a digital camera, it's just as easy to shoot in black and white. Charles Green also finds that, as he doesn't have to use a tripod or stand for his Fuji FinePix S1 Pro camera, he can shoot more flexibly. 'I could even roll on the floor for this kind of shot if necessary', he says.

06 Pioneer, settler, showman, publicist – however you think of Charles Green, there's no doubting the fact that he is at the leading edge of today's profitable photographic techniques. Why seven cameras? This is how many are needed for the investiture photography at Buckingham Palace.

07 Charles Green now uses the Fuji S1 digital camera for all his studio portrait sessions and produces enlargements up to 30x40 inches on his Epson Stylus Pro 7500 printer. Smaller prints are produced on his Fuji Pictrography 4000 printer. When producing many shots for a family portrait, the Pictrography will print four 8x6 inch or ten 5x4 inch prints on a sheet of oversized A3 in 60 seconds.

WHY GO DIGITAL?

BEING A PROFESSIONAL PHOTOGRAPHER IS PRIMARILY ABOUT RUNNING A BUSINESS. THE DECISIONS THAT YOU MAKE IN THE COURSE OF YOUR WORK CAN MAKE OR BREAK THAT BUSINESS VERY QUICKLY. GOING DIGITAL IS UNLIKELY TO BREAK YOU, BUT THERE IS A RANGE OF CONSIDERATIONS THAT HAVE TO BE EXAMINED BEFORE, AND MONITORED AFTER, MAKING THE CONVERSION.

Many photographers start off in the business because of an intrinsic love of the craft. There are very few who will stay in it for love, though. As much as your bank manager may like photography, he's not going to pay the mortgage off for you just because he likes your pictures.

The wedding and portrait market has become more and more crowded over the last five years. There are more and more photographers chasing the work, and few, if any, photographers will say they are working less and earning more.

Digital imaging is not a panacea for all your ills. A common theme in many of our case histories is that photographers are working harder and earning less profit.

This may seem a downbeat introduction to a chapter describing how digital imaging can help your business, but it is important that you decide the best path for your business and how best to spend your revenue.

There are three ways in which digital imaging can either save or earn you money. These need to be put into context with the amount you will need to spend in capital outlay (see Building a System page 66), but by carefully looking at the new revenue streams that digital can bring, and closely watching the daily/weekly expenses, you should be able to navigate the money minefield more easily.

Let's look at the good news about digital, which can be summarised as follows:

• Lower film and processing charges
• Increased bookings
• Greater sales per session

These are not guaranteed savings or revenue – they need to be worked at and you need to be strict about how your time is spent. But let's look in more detail at how you can maximise revenue while minimising expenses.

EXPENSES

How much does it cost you to shoot a portrait session or wedding? There's your time, the overheads (studio, office, car, equipment) the cost of proofs, prints and the cost of films and processing. Going digital will reduce your expenditure on proofing, film and processing costs. However, you are unlikely to recoup within a year the cost of an entirely new digital system merely by having fewer films to buy and process. With this in mind, it is worth calculating how much you spend on film, processing and printing. Having these figures will help you decide whether it is feasible to change over either partially or completely to digital.

Cheaper options

Cost savings can easily be achieved through digital imaging, even if only in terms of printing. Black and white printing is often significantly cheaper to achieve digitally than it is conventionally. And image manipulation is much easier to do digitally, meaning that labour costs will certainly be lower than traditional retouching. Whether the retouching involves spotting or more sophisticated image manipulation, digital wins hands down.

The expenses aspect of digital imaging can be compared to a car that is twice the cost of its competitors, but doesn't need any fuel. At what stage would it recover its cost? Digital cameras don't need film, but they do need computers and memory cards, and they run up image-output costs. In business, any level of expenditure can be justified if it generates more revenue and/or reduces other essential expenditure.

REVENUE

Let's look at the possibilities for revenue increases that digital imaging can bring to the equation. These can be split into two categories: increased bookings and increased purchases per booking. For those who spend thousands on advertising their services, the suggestion of increased bookings may bring a rueful

01 To produce this portrait, Karen Parker used the LightPhase digital back on her medium-format SLR. This combination provides the best of both worlds for her: high-quality images that can immediately be saved digitally for instant preview, or for manipulation and later output.

02

smile. But it is relatively quick to improve your reach in terms of how many people are aware of you, and increase the amount of information that can be delivered to potential customers. As we will discuss in the next chapter, improving communication with potential clients is not just about growing your business, it's also about protecting your business.

BOOKINGS

We live in an age increasingly dominated by consumers who are better informed, more demanding and better able to make comparisons. Your task is to provide enough information so that potential clients can approach you knowing that you are likely to offer what they want, or who are ready to hire you immediately.

Today, these goals are achieved first by having a good-quality website, which must be easy to find. If you are a member of a professional association, make sure that it has the most recent details about your website. Sign up for a listing in an online local directory, which you can easily find by carrying out a search for photographers in your area. Above all, ensure that any printed material clearly displays your website address.

In addition, your website is the perfect place where potential customers can come and see your work. You have complete control over the pictures that you show, how you show them, and it is a very inexpensive method of advertising.

SELLING IMAGES

It's very common for the bride and groom to buy portrait shots and pictures of their wedding to give to other people as gifts, but this source of sales has its limitations. Many people's modesty will prevent them from buying dozens of prints to distribute, and the couple may be struggling financially as a result of the wedding, which will prevent them from placing large orders. However, if you can market directly to relations and friends of the couple, you are more likely to increase your sales. Even if there are potential buyers who don't have internet access, they can still buy from CD-ROM proofs or contact sheets. These methods of promotion are significantly quicker and cheaper with digital imaging than with traditional photographic methods. As you can produce more proofs to hand around, you will avoid the standard bottleneck of the single album travelling slowly from one person to another.

02 'Outside at weddings, the Fuji S1 Pro is fantastic; it's great for grab shots and I find it works best on auto', declares Richard Lemon.

03 You can take as many pictures as you like with a digital camera knowing that there are no processing costs to pay. Once you've rejected those you don't like, any of the others can be offered to the client for sale.

Promotional ideas

Digital imaging allows you to shoot images of individuals and combine them so that each family can have all its members together on a specially large photograph. Finding out the names of the individuals can provide you with an excuse to give them your business card and contact details without appearing too pushy. Even the thorny issue of free portrait print promotions can be made less of a social service if others related to the client can be given the opportunity to buy.

When shooting weddings, you can distribute a handful of cards at each table at the reception giving details of how to order prints. If you have the equipment at the wedding - a laptop and an inkjet printer - you can even sell prints, or at least show them and generate orders. Having prints available gives the bride and groom a reason to promote you to their guests, which will enhance your chances of selling more images from the wedding.

Even if you don't want to go to the trouble of having a website, the very least you need is an email address, which many potential clients will prefer to use rather than licking a stamp and waiting days for your reply.

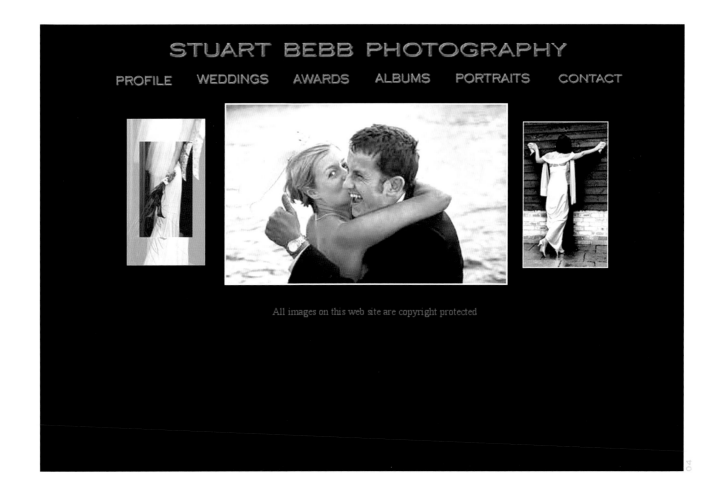

Value added

For studio-based photographers, the shop is the principal point of sale, but digital imaging opens up other possibilities. If you use a secure online ordering service, many people will have no problem with simply visiting a site and ordering from there. You can also offer a mounting and a framing service online to increase value-added sales. Any extra revenue you generate from a single shoot will offset other fixed costs, and once you have set up the internet-based infrastructure, the individual extra costs will all be covered by sales from that shoot.

04 Having a website is not merely a promotional aid, it is essential in order to get commissions in the first place.

05 Stuart Boreham is a prolific wedding photographer. He says that the more pictures you take, the more you can sell.

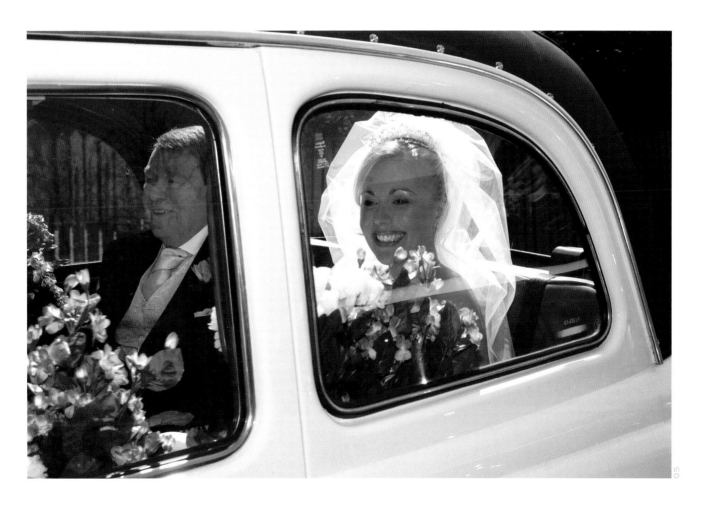

Speed

WITH DIGITAL PHOTOGRAPHY, SPEED MEANS MORE, AND
THERE ARE SEVERAL AREAS WHERE SPEED COUNTS.

An initial advantage that speed provides for wedding and portrait photography, particularly when shooting in a photojournalistic style, is that the more pictures you take, the more you can sell. Although there are limited speed advantages with digital compared to 35mm, it is significantly quicker to use a digital SLR rather than a 6x6 medium-format camera.

Digital imaging makes it possible to fit the equivalent of ten 38-exposure films onto a sufficiently large digital storage card, which means that you won't need to change cards during a session. In a studio context, this capacity is less useful because few clients would need that volume of images to choose from. Where the high volumes of digital storage are really useful is outside the studio when taking reportage-style portraits. Although it is relatively easy to replace the subject's closed eyes with open ones in Photoshop in the studio, it's far quicker to be able to double-up or treble-up on shots and get the right shot on the day. And if you do have to clone open eyes onto closed ones, at least you'll have a selection of shots with which to do it.

PRODUCTION ADVANTAGE

Another speed advantage with digital imaging is the speed of production of the final images. As hinted earlier, if you have the assistance available, you could produce images of the wedding while still at the reception and even make sales from a counter! It would be disingenuous to say that digital imaging is always faster than silver halide, but the bonus for any extra time invested in the production of digital images is that you have ultimate control over the final result.

FEEDBACK

A further area in which the speed of digital imaging scores over silver halide is receiving feedback far more quickly. You can show clients the preliminary results of a shot - even a second after a picture has been taken. Alternatively, you can email low-resolution images to a client so that they can see the results of the shoot in the time it takes them to travel home from your studio. It's also possible to offer an extra service to someone who could not attend a wedding by sending them a set of images during the course of the day.

There are many possibilities, but bear in mind that there might be a considerable gulf between what you can offer and what the client actually needs. Either too much information for them or too much work for you is likely to cause problems.

01-04 This series of portrait shots from a wedding taken by Eliot Khuner shows the ability of the digital camera to cope with quick changes of light for formal portraits and the ability to shoot unobserved and quietly for candid shots.

Quality

THE ISSUE OF QUALITY IN THE DAYS OF SILVER HALIDE
REVOLVED AS MUCH AROUND THE QUALITY OF THE PRINT
AS IT DID ABOUT THE QUALITY OF THE SHOT. DIGITAL HAS
CHANGED THAT.

It can be argued that professional photographers have always
been pursuing a level of quality in their work that amounted to
more than was actually needed. With the sole exception of a
very large group shot, with hundreds of people in it, there isn't
a situation where you can't use digital photography with
complete confidence.

Large group shots are the exception because people often
examine these shots closely to see particular individuals that they
would be unable to make out at a distance. And even in these
shots, the client is rarely worried about expressions. A greater
concern is likely to be the presence or absence of a key figure in
the shot because in all but the largest groups, the individuals are
usually identifiable. Some wedding photographers who use digital
imaging will sometimes use a medium-format camera on a tripod
for formal group shots. This equipment is useful for acting as a
focal point for the photographic session.

In the case of single portraits, you rarely need to reveal every
pore and blemish, and digital photography makes it easier to
defocus unwanted detail than silver halide photography. When it
comes to making blow-ups, the viewing distance increases with
image size. A 12x8-inch print is viewed from twice as far as a 6x4-
inch and contains the same amount of discernible detail for the
viewer. A 24x16-inch is viewed from twice as far again, and still
with no reduction in resolvable detail from that distance.
Providing that colour management for the imaging has been
brought under control, quality issues can be a red herring.

01 This detail shot
from a Kevin Wilson
wedding shoot
illustrates how
digital cameras
allow you to capture
fine detail; you can
also use colours
from these shots
as 'key colours' in
digital albums or
composited pictures
to complement the
bridal colour
scheme.

02 As well as
delivering high-
quality colour,
digital imaging can
deliver stunning
monochromes, like
this Karen Parker
shot. Digital black
and whites cost less
than film to print.

Quantity

AS WE HAVE SEEN IN RELATION TO SPEED IN DIGITAL PHOTOGRAPHY, THERE IS A MATCHING INCREASE IN QUANTITY. THIS IS NOT CONFINED TO THE TOTAL SHOTS THAT CAN BE TAKEN, BUT TO THE NUMBER OF COPIES AS WELL.

We've already alluded to the significantly increased capacity of digital storage media compared with film, but that is only part of the story. Once an image exists in a digitised form, making copies and moving images to different locations are quick and simple operations. There are several products available that can take memory cards and copy their contents to another device; some even incorporate small screens to identify the files being transferred. With the current rate of technological innovation unlikely to slow down, new storage media are guaranteed to continue to appear. CD-ROMs and DVDs are currently the preferred means of storing images, yet they too are likely to be replaced. But as long as the images are stored in a digital form, it will always be possible to copy them to the latest form of digital storage.

COPIES OF COPIES

Another aspect of digital copying is that nothing is lost in any copies that you make. If you make a copy of a copy of a digital image and then repeat the process 100 times, the amount of detail in the final copy will be exactly the same as in the original. This could not be said after only three or four copies of a silver halide image.

STORAGE MATTERS

It is also easy to store digital images by giving them meaningful filenames and placing them in a logical hierarchy of folders. This allows them to be located and printed again very quickly. Establishing a system initially can be time-consuming, but once it's working it should be quick and simple to operate. On the question of storage, it is also worth considering storing further copies of images with an off-site storage company so that whatever happens, your images are always retrievable.

DIVERSITY

An additional feature concerning quantity is the diversity of the subjects that you can cover. Trying to sell people photographs of their front door might not be immediately profitable, but if it has been decorated for the wedding day and you include it as part of the wedding collection then you may find it eagerly accepted.

Similarly, close-ups of rings, shoes, bridesmaids' hairstyles and headdresses, and even church clocks can all be sold, if not individually, then as part of a larger combined image. The capacity and speed of digital cameras allow you to do this cost-effectively and quickly.

01 & **02** Stuart Boreham can afford to include some fun shots at the weddings he covers, such as the reposing hat model (left) and the videographer in the maze (top right).

03 The smallest details can make the difference in the complete picture of a wedding day. This Kevin Wilson shot would never have been taken on a medium-format camera, but on a digital camera it was a quick point-and-press.

04 Getting a sense of occasion is much easier when albums can be put in context by small, almost abstract shots, like this Eliot Khuner picture.

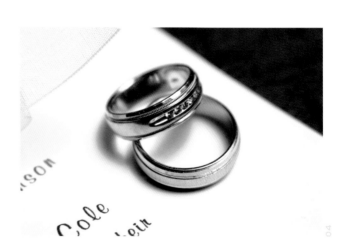

Flexibility

THE FLEXIBILITY OF DIGITAL PHOTOGRAPHY IS APPARENT AT MANY LEVELS. AT THE LEVEL OF PIXELS, EACH CAN BE CHANGED INDIVIDUALLY. AT THE LEVEL OF PRESENTING A PORTFOLIO, IT'S POSSIBLE TO CREATE A MUSICAL.

An essential feature of digital imaging is that the whole process covers a multitude of technologies and techniques. A portrait or wedding client may simply want a set of formal shots, or they may want total coverage of the event to give them a wide variety of shots to choose from. Because of the versatility of digital imaging you only need one set of equipment irrespective of what type of commission you have. You need no different speeds, or types, of film to choose from, no filters nor different lighting. This aspect of digital photography has the initial effect of reducing capital outlay, with the proviso of course that you will need to upgrade and replace equipment over time.

SHAPING AND SHARPENING
Another aspect of the increased flexibility of digital over traditional film is that of orientation and cropping. If a shot is not perfectly horizontal, it only takes a few seconds' work before the shot is ready to print. Cropping-in and changing the shape of the image can both be done in a fraction of the time than would be the case with traditional photographic methods.

However, one of the most useful features of digital is that it offers a few simple techniques, such as sharpening and blurring, that allow you to create commercially viable shots from what would otherwise be snapshots. The technique known as sharpening, which involves digitally increasing the contrast around the edges of subjects and enhancing perceived detail, should only be used in moderation if your images are to retain a sense of the natural. The opposite technique of blurring can be used extensively and, more importantly, invisibly to increase the impact of a shot. Although this technique cannot be fully automated, software is available with which a variety of degrees of 'haze' can be achieved.

Having the flexibility to create an image of any shape, colour, orientation and virtually any size can be hugely persuasive when a client is deciding to choose you as their photographer. Having the flexibility to remove intrusive backgrounds or indeed intrusive people can be a huge bonus when it comes to presenting shots that clients want to buy. Whether your images are digitally captured or scanned from film, virtually all the benefits of digital imaging apply equally to both, with the obvious exception of the expense of film.

BEYOND THE IMAGE
Finally, as digital images are effectively a blank canvas, the addition of text, the production of mock newspapers, of adding sound or turning a series of pictures into a slideshow accompanied by music are all open to the photographer, with the usual caveats concerning cost and time.

01 Although most people tend to think in terms of colour for digital photography, this Karen Parker shot shows how it is possible to control tones in monochrome digital imagery.

02 This picture would be extremely difficult to print in a conventional darkroom without an anamorphic enlarging lens. In Photoshop, Karen Parker performed this manipulation in seconds.

Artistry

DIGITAL PHOTOGRAPHY IS MOST COMMONLY SEEN AS A REVOLUTION IN THE MECHANICS OF TAKING A PHOTOGRAPH. BUT WITH DIGITAL MANIPULATION, IT'S A REVOLUTION IN CREATING THE FINAL IMAGE.

Not every professional photographer is going to be a trained artist or highly skilled in Photoshop, but simple effects such as adding a border, adding text or intelligent cropping will make an impression and are easily achieved. Adding a thick border to a smaller image creates a larger image, which can be sold at a higher price for less than a minute's work in Photoshop.

UNIQUE IMAGES

On the next level up, you can make a feature out of your artistry. Whether in the form of the increasingly popular digital album, or by the specific manipulation of images, there are opportunities in the digital arena that do not exist with film. Helen Yancy (see page 46) goes one stage further by making her artistry the key selling point of her business. Helen uses the Painter program to transform her digital photographs to produce unique, one-off images, and they are sold as such.

Taking a print and applying, for example, sepia and split toning, are acquired skills. Additionally, dipping the print in toner, washing and drying it before being able to decide if the right effect has been achieved can be a lengthy process. Using imaging software, sepia, blue and split tones can all be achieved in seconds. When you have a blushing bride, or a nervously flushed one, a sepia-toned or black-and-white image may lead to a sale where a full-colour image of crimson cheeks may lose you one.

COMPOSITING IMAGES

Much can also be achieved by using the compositing technique, where separate images are carefully selected and super-imposed to form a single image. The only caveat with all of these possibilities is that you don't want to overwhelm the client with choices, and neither do you want to overwhelm yourself with work. Not every client has the means or the desire to take advantage of all the opportunities afforded by digital imaging.

01

01 This subtle portrait, by Helen Yancy, shows how a digital manipulation program allows the manipulator's artistry to be maximised. From the soft-edged border to the application of a watercolour painting effect and its combination with the digitally captured facial and hair detail, this image looks simple, but would have taken weeks to achieve with traditional retouching.

02 Digital image manipulation allows the alteration of hue, saturation and brightness to suit the subject. In this case, the keynote colour was taken from the subjects' hair and then imposed on all the colours in the image.

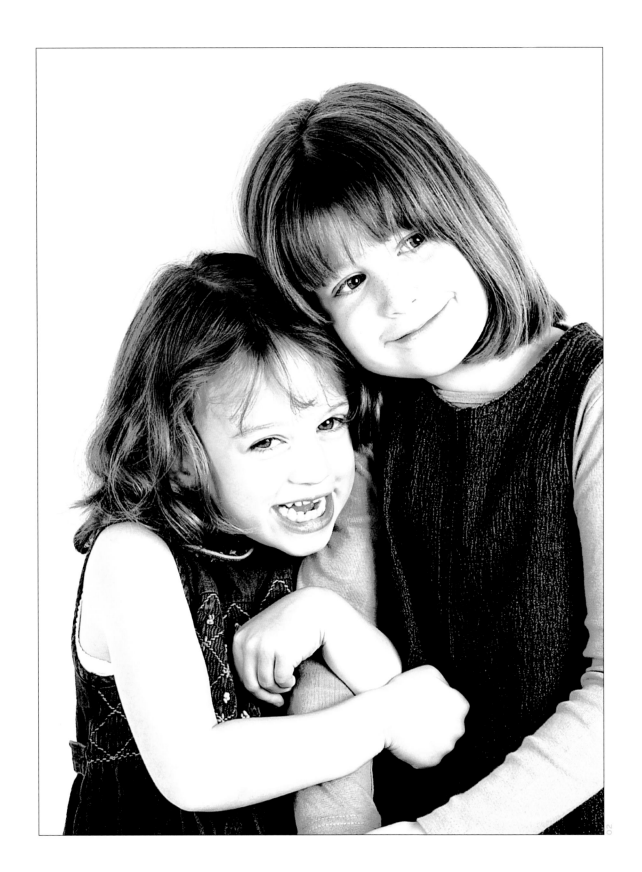

RICHARD LEMON
'Go for it. Get in there and learn'

Richard Lemon runs a busy studio in Brighton – a very busy studio. The reason why he moved to digital imaging was a very simple one – he did a lot of portraiture and was spending a mountain of money on film and processing.

'We used to work on the 'blad', he remembers, 'and since we switched to digital the minimum we're saving is £5 per customer. That's for the absolute minimum number of shots. With some clients it will be three or four times that.' So what impact does this figure have on his business? 'We see 1200 people a year. You can do the sums yourself. We managed to pay off the cameras and computers within three to four months on cost savings alone.'

SAFETY ISSUE
In addition to offering savings on film and processing costs, there are other benefits that he's identified. 'Quality-wise, the digital is fantastic. A friend of mine got the same camera as me and he was having variable results from inkjets so I decided to go via the digital lab route. For me, the difference between digital lab and the inkjet is a sale. Digital silver halide is like sending your negs off but keeping them safe at the same time.'

LOW-LIGHT ADVANTAGE
As well as his studio portraiture, Lemon covers weddings, where he feels the S1 Pro really comes into its own. 'Outside at weddings it's fantastic, it's great for grab shots and I find it works best on auto. I've done all sorts of tests and the automatic exposure is as good as anything else. Also, as you get older, the AF is a real boon. The one trouble is that the sync speed, which is only up to 1/125 sec, is a bit restrictive for daylight fill-flash. But the

01 Although images are captured in colour on a digital camera, the output can be in whatever form best suits the subject. In this shot, the speed and storage capacity of the camera allowed Richard to grab the moment he wanted. The results were then output to photographic paper in black and white to achieve a classic look for this contemporary image.

02, 03 & **04** The ability to rate the camera at an effective speed of ISO 1600 means the difference between getting a usable (and saleable) shot, or not. In these three images, Richard pushed his digital cameras to the limit to capture both scene-setting shots (**02** & **03**) and the beginning of a Christmas wedding ceremony.

05 Using a handheld digital SLR instead of a medium-format camera on a tripod allows the photographer to give a more natural look to what could otherwise have been a stilted shot.

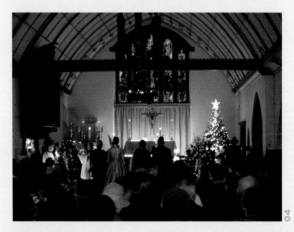

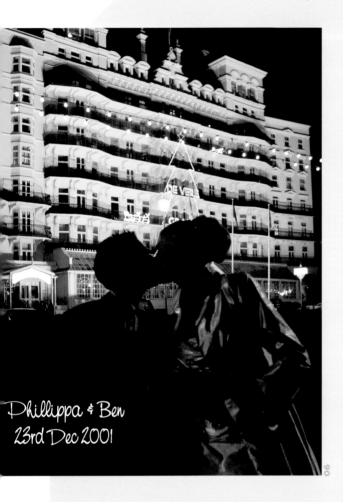

Phillippa & Ben
23rd Dec 2001

camera scores when the lights are low. I had a Christmas wedding last year, with Christmas tree lights and candles, and I just couldn't have done that with a Hasselblad. Even on ISO 1600 the results were acceptable. When I pulled the images up on screen they were very grainy but when that was transferred to a silver halide print, the grain, whilst still there, was nowhere near as intrusive.'

POSITIVE FEEDBACK

But has he had any negative reactions from customers about digital? Rather the opposite. 'When people come into the studio, a lot of them will say "digital, ooh that's good".'

How did he come to make the decision to switch to digital? 'Photoshop has always been there, and a few years back when restoring a picture on screen I thought, "I could add that to the business". I've seen four people who walked in off the street for restoration work today.'

And what's his view of the results so far? 'I really took my time to test that the quality was there, then when I was satisfied I just switched completely in the studio. We take more money because we take more pictures. We enjoy it more and we experiment more. We're selling more pictures all across the board. We've got different pictures to show for digital. That's how I see it. I wouldn't have got those without it.'

So very positive then? 'My advice to those about to take the plunge?' he asks. 'I think it's fantastic. The quality is fantastic, as good as if not better than film. It's a different look – cleaner. Go for it. Get in there and learn, although you don't have to learn that much.'

06 Richard's use of the high sensitivity of the camera, the use of a restricted colour palette and the addition of a quick text caption mean that a complete wedding has been encapsulated in a single shot.

07 Careful composition allows this shot to set the scene for a Christmas wedding. Using a digital camera enabled the image to be captured in the first place.

08 & **09** Richard's studio is set up so different subjects can be captured quickly and accurately thanks to the dedicated (and pre-tested) lighting rigs for different areas of the studio. The choice of monochrome output for these two shots really makes the difference between a 'nice baby' shot, and a portrait that people are happy to pay for.

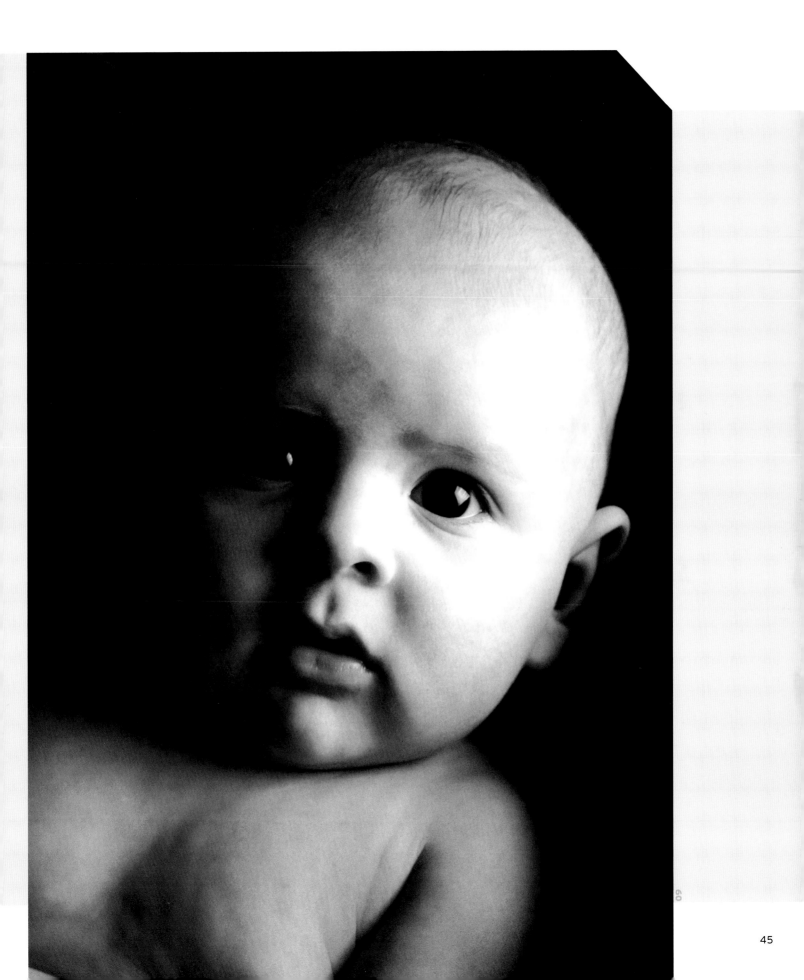

HELEN YANCY

'There still isn't a button on a computer ... that can do what I have to do'

Helen Yancy collects awards like the rest of us collect loose change. She is the first person to earn all four PPA Degrees (Master of Photography, Master Artist, Master of Electronic Imaging, and Photographic Craftsman).

Helen brought together the British Institute of Professional Photography and the Professional Photographers of America for the first international competition in the UK in 1997 and has been there each year since to help forge a stronger bond between the two groups. In 1997, Kodak awarded Helen with the very first International Honorary Gallery Award. A year ago, she was invited to the United Nations to receive a Medallion for leadership, service, artistic and photographic ability by the International Council for Photography. She has almost 900 Merit Awards from PPA for artwork, paintings and photographic work. In addition, Helen has twice been Michigan Electronic Imaging Photographer of the Year.

DIGITAL PORTRAITURE
Helen is passionate about life, family and art. She is passionate about people, and especially their faces. She started with oil portrait paintings, capturing the true essence of her subjects, but more recently has taken to the limitless palettes, brushes and tools of the digital world. Helen's adventure into portraiture with twenty-first century media combined with old-master style and ability has renewed her excitement and challenged her to expand her own horizons. Her favourite subjects are children, and she describes digital imaging as 'the biggest love, and biggest headache I have apart from my family. I'm working way more hours than I used to, but I'm having a wonderful time.'

Her route into digital imaging was different from most because her background is in retouching. Her business is also a little bit different from most portrait photographers. Her sales are one-offs, and deliberately so. 'Most people come to me because they want to have a watercolour, and while we certainly do straight photography as well, mostly I'm doing portraits and images in [Corel] Painter.'

CONVERTING TO DIGITAL
So how did she get started? 'I was a speaker at the Wisconsin State convention, which was PPA-affiliated, and I had done a print critique during which I'd said I was never going to use digital. The very next day I went to a digital demonstration and within six months I was refusing to do traditional retouching.'

Her conversion is a complete one. 'Everything starts and ends in Adobe Photoshop with Corel Painter in between. I shoot everything on digital, and I occasionally panic when I have to shoot a really big image, but as I'm painting with the digital images, resolution is not always a big issue.'

Given the nature of her work, turnover is not really the issue either. 'If I do two jobs a week I'm happy. If I'm really

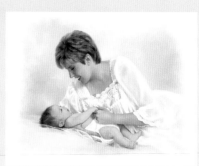

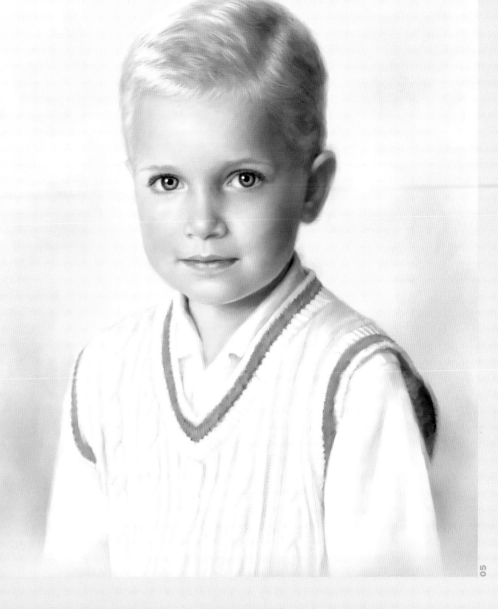

busy then it's sometimes up to four or five. First of all when I switched to digital, I was doing artwork for other photographers. When I first started to turn [traditional] work down, I was in a position where I could say it [digital] was genuinely better [than airbrushing]. And when I went solo I decided to play down the fact that I was using digital imaging, and to this day I refer to my work as hand-drawn as there still isn't a button on a computer that can do what I have to do manually.'

EXCLUSIVITY

While the vast majority of photographers look for the highest possible number of resales of their work, Helen has chosen to keep her work exclusive. 'We don't sell two copies of the watercolour. No one else has the image, and it works. We will sell to another family member, but not the same image, only one from the same session.'

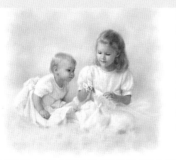

01, 02, 03 & **04** Helen Yancy's pictures have a unique look all to themselves. Their characteristic combination of digital photography and fine-art electronic manipulation comes from their author's background in photography, painting and retouching. These disciplines allow Helen to create images from digital photos as opposed to images of digital photos. By blending captured pixels with softened watercolour-style renditions of the actual background, or even introducing new elements as a focal point for the subject's interest, she creates images that are more than the sum of their parts.

05 Some of Helen Yancy's images are complex manipulations of combined elements. Others are equally sophisticated in their creation, but appear powerfully simple in their finished form. This portrait shot combines the look of a painting with the depth of field effects of a photograph to give a modern take on traditional portraiture.

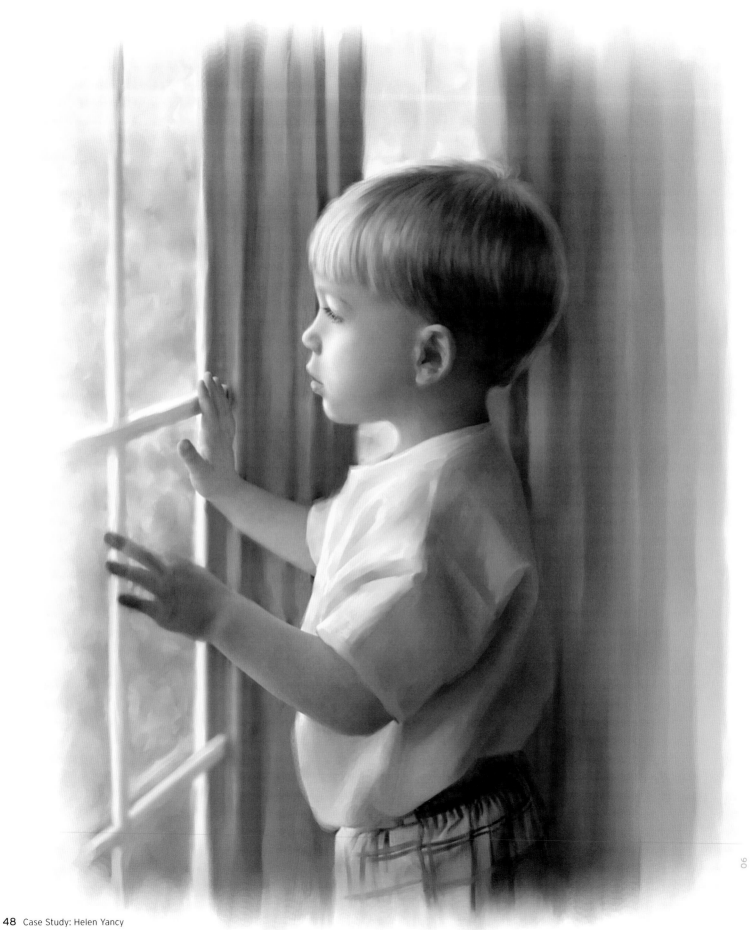

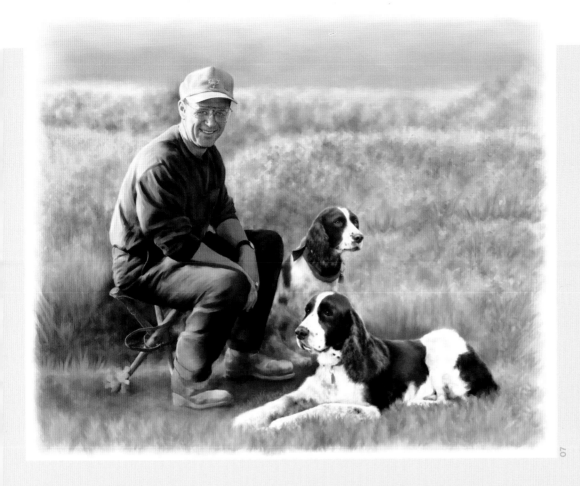

07

06 Often the most successful manipulations are those that are almost unnoticeable as manipulations. This natural portrait was created from a digital camera image, and subtly blended until the effect was just right for the subject.

07 Animals are notoriously difficult to pose successfully in photographs where they are not the sole subject. Digital imaging allows the combination of different images to create the desired finished product. And if the background is unsuitable, simply place the desired elements of a photograph onto a background that is more effective.

08 Sometimes the simplest effects work best. This digital photo has just the bare bones of a portrait – head and shoulders – but it works well because of the vignette treatment and painterly effect.

This means that the images have to be good enough to justify the fee that exclusivity demands. 'What we do with the images is either to print onto French imported watercolour paper or Epson Canvas. In terms of inks, all are pigment-based for archival reasons. We don't sell anything with dyes.'

COST CONSIDERATIONS

As her pictures are one-offs, Helen's commercial side is a little different from most businesses. 'I don't have a website because I don't have time. For me, I honestly feel that the people who say how much their costs are going down are forgetting the capital costs and also that you need to get someone to do your other work or the pre-press and workflow. Sure it's wonderful that we're not spending money on processing. Now we have to do all that ourselves! But I still don't regret switching to digital and I'm so excited about what I'm doing that sometimes my family is neglected!'

08

WHY GO DIGITAL NOW?

DIGITAL PHOTOGRAPHY MORE THAN MEETS THE PROFESSIONAL PHOTOGRAPHER'S STRINGENT CRITERIA OF QUALITY, QUANTITY, FLEXIBILITY, SPEED, CONTROL, COST AND ARTISTRY. THAT'S THE ANSWER TO 'WHY GO DIGITAL NOW?'.

One of the traditional answers to the question 'Why **not** now?' has been that the quality of digital imaging was inferior to film. In the early days of digital imaging, this was certainly true, but the rapid rate of development during the last five years has made that view invalid.

In the case of scanning from negatives, for example, it is possible to scan all the dye clumps that form the image. There is obviously little point in doing this, but it does demonstrate that all the information in a negative is completely retrievable using digital means. If the manipulative possibilities offered by image-editing software are added to this depth of retrievable detail, then it is clearly apparent that better pictures are available from a digitised image than from traditional film-based methods. Furthermore, the fact that adjusting digital images is quicker and cheaper than film images must also be emphasised.

A DEVELOPING TECHNOLOGY

A further aspect of the quality question concerning digital cameras is that the resolution and the power of on-board processors are, and will continue, to increase. The technology of film-based processes have reached a plateau where all the major advances now lie in the past. But electronic technology is still in its infancy and, as it matures, so will all the applications that have arisen from it, including digital imaging. The existing clear advantages of using digital in the field will also soon be unrivalled in the studio.

There will be Luddites who argue that the complexities involved in digital imaging compare unfavourably with the simplicity of film's 'load, shoot, process, print' cycle. However, the introduction of simple colour management to silver halide printing from digital files will be one of the deciding factors that will lead to digitally captured imaging becoming the format of choice for professional photographers.

01 Stuart Bebb uses a combination of digital imaging, shooting on film and manipulating the scans. In this case, the crop is the manipulation to create a dynamic, high-quality portrait.

02 This shot is from one of Karen Parker's personal projects. It illustrates the sheer quality of detail that is available to the digital studio photographer.

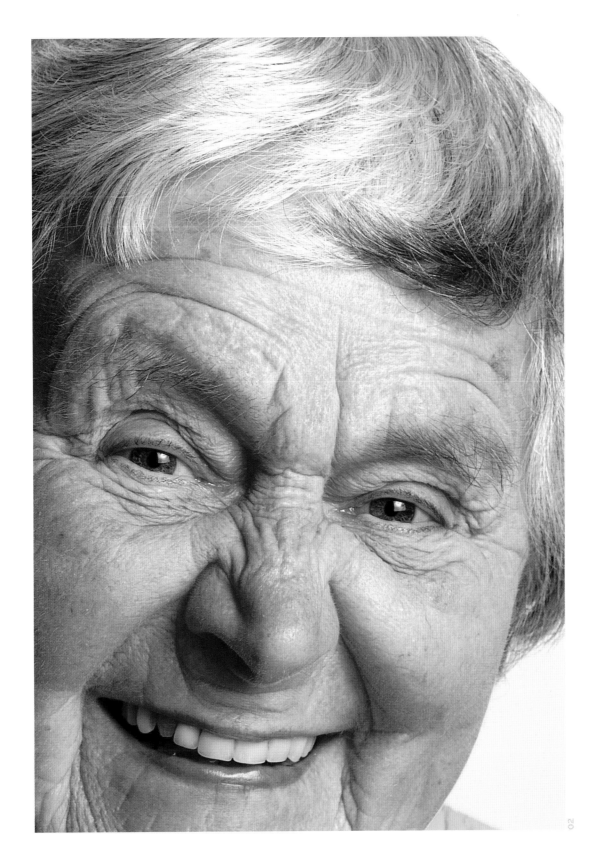

The internet

THE INTERNET IS NOW A FACT OF LIFE AND IS POSSIBLY THE GREATEST DEVELOPMENT IN HUMAN COMMUNICATIONS SINCE THE INVENTION OF PRINTING. AS A COMMERCIAL TOOL, IT HAS TO BE PART OF YOUR OPERATION.

Ever since it was created by the US military, and made user-friendly by a Briton, Tim Berners-Lee, who bolted on the World Wide Web, the internet has expanded at a staggering rate. Nearly 50 per cent of homes in the UK now have internet access, which means that the internet is having an effect on the majority of people in the UK. It's a cliché to say that the internet is changing many aspects of our lives, but that doesn't make it any less true.

LOCATING A PHOTOGRAPHER

Take the question, 'How do people choose a photographer?'. As little as two years ago, the answers would have included: from the Yellow Pages; by personal recommendation; at a wedding fair; seeing a local newspaper advert; taking up a cheap print offer put through the letter box or by consulting a professional body. The numbers will be different for each location and niche of the photography market, but now the number of people who are making their choice of photographer on the basis of a website is rapidly increasing.

Search engines let you look for specific products, services and information on the net and receive thousands of results, or hits, in less than a second. If you type "wedding photographer" (including the double quotes) into www.google.com, you will be provided with about 22,700 responses. Adding the letters 'uk' (excluding the single quotes) and repeating the search still produces nearly 4000 hits. Among these websites you will find professional photographic associations, agencies offering services, directories, and other related commercial sites as well as the wedding photographers themselves.

HAVING AN INTERNET PRESENCE

If you do not have a website, or haven't signed up with one or more of the many agencies or directories that can provide you with a web presence, then no matter how individual, memorable, excellent and affordable you are, you will remain invisible to a large number of prospective clients. Signing up with an agency is the simplest way to become net-visible, but if you want to explore the possibility of having your own website and don't know how, just type "creating a website" in Google and more than 2000 sites will be listed that might help.

For a commercial photographer, a website effectively makes your shop window available in people's homes so that they can see your work. This immediately removes both the uncertainty a potential client might have about your photographic style and the difficulty you might have about describing your work over the phone.

MARKETING POSSIBILITIES

A website allows you to present different packages where the clients can find out the whole range of what you have to offer, irrespective of their personal budget. The flexibility of a website also allows you to increase your range (and therefore the price) of packages. A wider range may persuade the prospective client to abandon the low-end, budget deal that they intended to buy, and to raise their ambitions and be seen as more upmarket clients. By placing different styles and different options on your website, you might also persuade them to plan additional purchases even before they have contacted you.

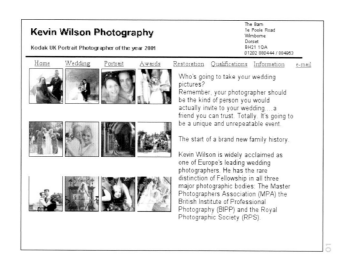

01 Kevin Wilson's website follows the important rule that you should show and tell what you offer. Clear, concise text details his qualifications, awards and philosophy, while an attractive range of sample shots invites the casual visitor to explore the website more fully.

02 Don't be afraid to blow your own trumpet on your website. Potential clients want reassurance when choosing a photographer that they are getting the best one that their money can buy. False modesty will undermine their confidence in you. You may have ten seconds to convince them to go further into your website. In other words, their first impression may well make their decision for them. Make it a good first impression.

03, 04 & **05** Keith Thompson's website has a clear message: that not all photographers are the same. He backs up his message with a selection of shots for potential clients to view that show the range and quality of his photography, and the kinds of effects he can create to deliver the perfect finished product.

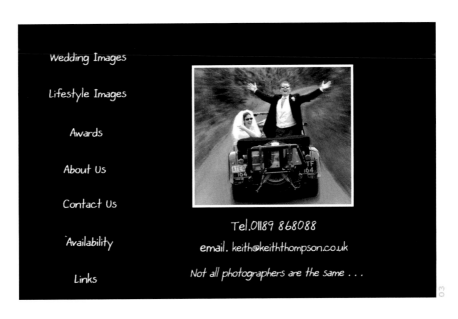

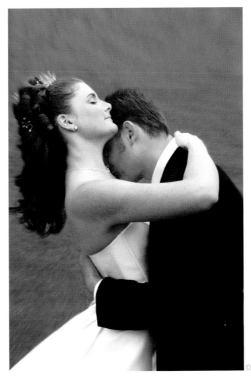

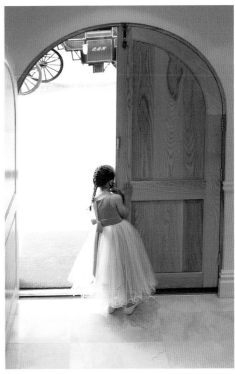

01 If you've got it, flaunt it. Won awards? Tell people about them. Have professional qualifications? Use them to underline your professionalism. People may not read all the way through such a long list, but the length of it is as important as what you say.

02 There are no hard-and-fast rules as to what makes a good home page. Some photographers like simplicity, others like variety. The kind of photographer, and even the kind of person you are, should be reflected in your home page.

Online sales are unlikely to become a money-spinner the day you launch your website. At some time in the future, these sales may become a significant part of your portrait and wedding sales, but this is unlikely to happen overnight. The essential feature of the internet is that it is an electronic space of galactic proportions where it's very important for businesses to have a presence. By having a website, you are at least giving prospective clients the option of finding you, seeing your work, and contacting you.

SALES MECHANICS

Your clients can simply choose how many pictures they want when buying online. This means that they don't have to write cheques and deal directly with the amount involved when making online purchases. This fact makes online shopping a much more laissez-faire form of shopping than the traditional face-to-face form conducted across a counter. And internet users are less inclined to worry about amounts of less than £50 than they would if they had to use a cashpoint and physically hand over the cash.

ADDITIONAL SALES OPTIONS

A powerful sales option is to give clients a password-protected site where they, their family and their friends can browse through the whole portfolio of a wedding for as long as they want. This has the effect of making them all feel as though they are members of an exclusive club where they can choose the pictures they want to buy. This may seem complicated, difficult to set up and possibly an irritating extra expense, but as long as you break even on costs versus sales, you are offering the client an added extra. You can, of course, insert this option as a chargeable cost if you wish. More and more clients will have friends and family with disposable incomes who are very comfortable buying from the internet. Every guest can view the pictures, at any time and from anywhere in the world, and simply order the pictures online.

Your website's Internet Service Provider may charge you on a scalable level depending on the amount of space you are using. If this is the case, you can use the opportunity of the pages having to be removed as an extra reason to get the client to badger their friends and relatives to log on quickly and make a purchase 'before it is too late'.

03 & **04** Richard Lemon's website has a unifying colour scheme. Even though the individual pages differ dramatically in style and layout, they obviously 'belong' together, and give an impression of organisation and unity, rather than something that has been haphazardly thrown together. Templates, or the use of a limited range of colour tones and fonts, all lend coherence to a website without removing the ability to mix and match different elements.

You are not alone

COMPETITION IS AN INESCAPABLE FEATURE OF THE
MARKETPLACE. VITAL FACTORS FOR SUCCESS INCLUDE
MEETING YOUR CLIENTS' WISHES AND CONSIDERING THE
TYPE OF BUSINESS YOU RUN.

Making preparations for the worst in business is a judicious move.
Strong competition has always been an inescapable fact of life in
commercial photography, but the internet has made it possible
for photographers outside your immediate location to take your
business away. In the case of wedding photography, there are few
photographers who are not prepared to travel for a commission.
So now you are not only competing with other photographers
within your vicinity, but with all of those within a few hours' travel
of your area.

CLIENTS' WISHES

If you are not offering a service that other photographers are,
then you may find that you attract less business. There are ever
more professional photographers running businesses. Belonging
to a professional association may give you some insulation by
having potential clients being pointed in your direction, but
ultimately the services you offer, or more critically, those you
cannot, may be the crucial factor in whether a potential client
decides to use you. Whether you prefer to shoot formal or
informal portraits, whether black and white is a medium that you
love, tolerate or despise, the clients' wishes are considerably more
important factors when deciding to choose you.

TWO TRADING APPROACHES

There are two equally successful ways of trading: turnover-based
and premium-based. The examples of Richard Lemon and Helen
Yancy respectively in the case studies makes that distinction clear.
The former has many clients spending a relatively small amount
of money, the latter a few clients spending a great deal.

The location of your studio will have a strong influence on
what sort of business you run, how you advertise yourself, and
will also define the competition that you will face. This is true to a
degree for the wedding market as well.

Whichever of the two approaches best describes your
business, you need to make sure that people are aware of your
particular speciality while making them aware of the other
services that you can offer. If your work is not sufficiently
individual and flexible, you will lose out to those whose work
is. Something as small as not being able to offer the choice
between black-and-white or colour on any given shot may be
the difference between winning or losing a job. It is impossible to
know what a client wants until you speak to them, but being able
to answer 'yes' to all of their enquiries, and knowing that you can
meet their needs, is a major plus in the winning over of a
potential client.

You need to engage in what looks like an apparently
contradictory pattern of behaviour to survive in today's tough
commercial world. On the one hand you need to have something
different or even unique to offer potential clients. On the other
hand, you need to be able to offer the full panoply of current
styles and finishes to keep up with your competitors.

01 Nobody likes it when a client takes an example of your work to another photographer and asks 'can you do a picture just like this?'. Unless, of course, the competition can't. However, if somebody comes to you with a concept like Karen Parker's adventurous composition and colour usage and asked if you could match it, the only answer the potential client wants to hear is 'yes I can'.

02 Trends and fashions have come much more into portraiture and wedding photography. It's no longer enough to say 'twenty prints in an album' to many clients. If you don't offer them something creative like this Stuart Bebb magazine-style layout, you should be sure that someone else will. You don't have to shoot every job in the latest style, but you do have to be able to offer that option.

STUART BOREHAM
'The benefits are pretty much all the clients"

Stuart Boreham started as a GP photographer then went into weddings providing what he describes as a 'natural experience' – a non-intrusive, organic form of wedding photography. His motto is 'no softies, no interruptions' and he has been using digital cameras exclusively for a year.

Stuart is refreshingly frank about both the benefits and the downsides of the complete switch to digital photography that he's made. 'I'm making less money and it takes more time', he sighs. But that is in part due to the heightened expectations of his clients, and the ever-increasing competition within the marketplace.

LABOUR-INTENSIVE PROCESS
'Although I've had people tell me about how easily you can automate things, you still need to go through and check each one. It's getting to the point where I think I may hire a technician to do it for me. I can check and correct 500–600 images in six hours or so. But it's really eating up my time. Until printers take the same kind of responsibility for digital as they do with traditional film, then digital is still going to be very labour-intensive for the photographer.'

USING THE INTERNET
Stuart also advises caution about how much you publicise the digital aspect of the work. 'I've lost at least two bookings because people were concerned about the quality. When it comes to weddings, particularly with reportage-style stuff, it's much easier and safer in some ways with print film from the client's perspective.'

One area where Stuart has noticed (and indeed led) the changing face of the wedding and portrait marketplace is the internet. 'When I started using the internet four years ago, I was one of the few photographers on the web. Now virtually everyone is on there.' Stuart has sensibly compartmentalised his web presence so that if you want his commercial photography you are directed to one site, while his portraits are on another, and his wedding albums and resales are handled by www.everybodysmile.co.uk.

He has also developed links to a large number of wedding websites, so he can be found from a huge number of different directions on the internet.

EXPOSURE ACCURACY
Stuart's determination to give his clients as much choice as possible drives him to shoot hundreds of images during a wedding. And this itself is not as straightforward as it seems. 'The camera is set on manual colour balance and I'm now setting it on manual exposure to be absolutely sure about exposure. With the Nikon D1 it's always worth sticking a flash on it as it gets it [the balance of daylight and fill-flash] right consistently.' His rule about digital is, 'You mustn't overexpose it. Automatic metering or flash metering when you are shooting black suits can cause complete white-out of facial tones. I constantly keep metering to get consistency and accuracy of exposure.'

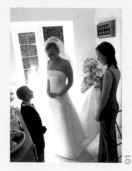
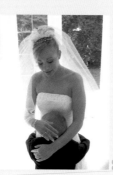
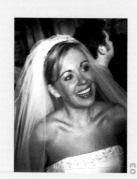

01, 02 & **03** Stuart's prolific shooting rate is rewarded by a plethora of small moments that really capture the emotions of those closely involved in the wedding. To add to the documentary feel of the pictures, these were reproduced in black and white.

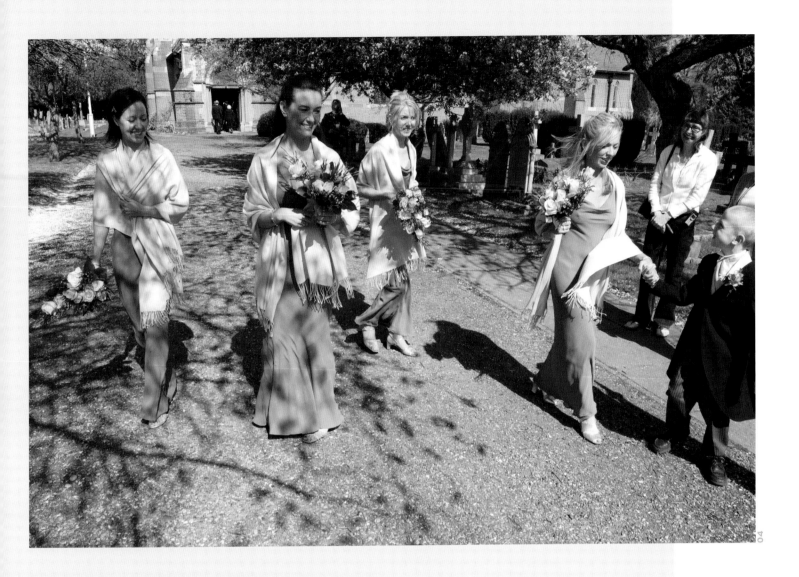

04 Although Stuart's shots have the compositional look of a documentary photographer, his GP background makes him a stickler for manual control of exposure and white balance.

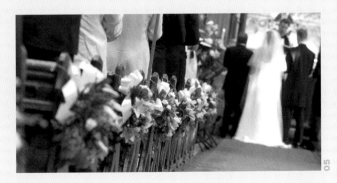

05 By choosing non-traditional composition, focal point and depth of field, Stuart has been able to give the viewer the feeling that they are actually in the aisle leaning round to get a better view.

06 & **07** The choice of colour or monochrome can make a tremendous difference to the way a shot is viewed. But these days there is no question that albums can contain a mixture of both and still deliver a consistency of style.

08 A lot of clients prefer that the style of the wedding isn't completely serious. Moments captured outside the traditional stilted realm of the traditional wedding can be big sellers.

GOOD FOR THE CLIENTS

The problem with shooting as prolifically as Stuart does is a fairly obvious one. 'I take 500 or 600 shots and every one of them has to be colour corrected or tweaked in one way or another.' The benefits are pretty much all the clients'. 'They like that they can see all their wedding pictures online and also that I print my own albums.'

He finds that his clients across the whole range of the market are becoming more sophisticated. 'They are also getting a lot keener on price and negotiating. The way I run things is that the clients pay a flat fee for which they get all the pictures. Relatives can choose individual shots for reorders if they want.'

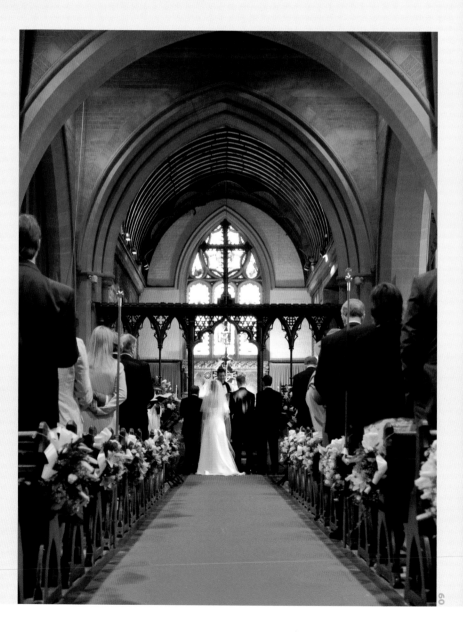

LONG-LIVED PRODUCT

As far as his physical output is concerned, Stuart has gone down the inkjet route for output, but is confident about the longevity of the product. 'In the US, the product I use is described as archivally permanent, and in such a litigious society, you can only assume that they're not taking any chances.'

When he's not thinking about the lost time, you can get Stuart to be positive about digital imaging. Here's his summary on the technology in use. 'For portraits it's great as there's no need for proofing. For formal weddings it's great, as it's quick and you can double-up or treble-up on shots.'

09 Complex mixed lighting shots are still as complex with digital imaging as they are with film. The difference with a digital camera is that you can choose which area is going to appear neutral, or even shoot with a variety of white balance settings to get the best look.

10 Although the flexibility of digital means that you are not restricted to formal shots, the bride and groom are still very likely to pick a 'couple' shot to be blown up. The difference is that you can shoot dozens for them to choose from without them knowing you are doing it.

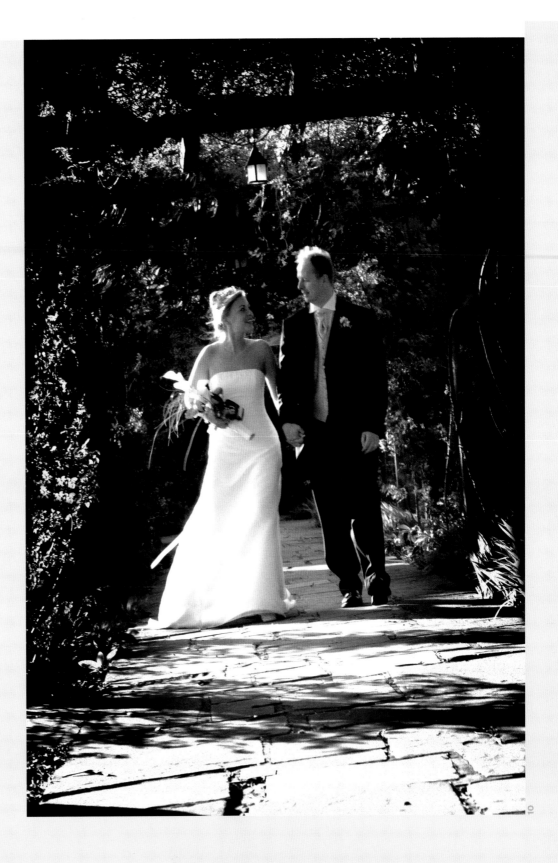

KEVIN WILSON
'I can really let rip and can just keep shooting'

Kevin Wilson is the consummate professional wedding and portrait photographer. He has won 17 European Gold awards and around 300 other awards, has fellowships from the Master Photographers Association (MPA), the Royal Photographic Society and the British Institute of Professional Photography (BIPP), and was president of the MPA in 2001.

Kevin's is a practice steeped in the traditional methods, but he has always incorporated new techniques and technology when the quality and usability was right for his business. His progression to digital has been an evolving one.

'More and more couples want "reportage" – in actuality photojournalism with smiling – and this has made a real difference to how worthwhile digital is. I don't even mention the word digital to clients. I was going out with a Nikon F100 and doing traditional stuff with groups. But instead of the F100 I'm now using digital SLRs. All my candid photography at weddings is taken digitally – with a Fuji S1 and Nikon D1X. Because I use zoom lenses – a 28-70 on the Nikon and the 80-200 on the S1 – I can work really quickly and I'll get head and shoulder pics of people on the S1 and closer-in stuff with the D1X.

ALL-IMPORTANT COSTS
'Where I was getting 36 6x4 prints for £25 plus VAT each (hand-printed), or a roll of 120 at about £15, I now shoot the equivalent of eight or nine rolls at a wedding as the price of printing digitally is 36 exposures for £6.95. So I'm saving a huge amount – especially on black and whites. Not having to worry about cost, I can really let rip and can just keep shooting. I'm now using multi-format albums as 6x4s can be used in any orientation on a single page.'

On the business side, Kevin charges in two ways. With weddings it's an all-in-one package, but when it comes to the print reorders, the clients are ordering on the basis of expressions. I always feel with digital you pick up more detail. When you shoot film in dark settings, the shadows "bludge up" whereas digital keeps the detail. More good quality pictures to choose from means more images that can be reordered. And digital helps with that.'

IMAGE PRODUCTION
Kevin is pragmatic about how much work he does on images. 'I'll edit all the originals, and sometimes do a bit more involved work on the shots. I've just had one where the bride's mother-in-law's arm was poking into an otherwise perfect shot. I was able to remove it, which I wouldn't have thought about doing before digital imaging.'

As far as proofing is concerned, again the key factor is time. 'To be honest I just haven't got the time to spend printing out images on inkjets. I bring the images into Photoshop, check and correct the levels, then the same with the contrast and add a bit of saturation, and send them off to the lab. They're all at the native resolution and I get them all printed at the size I want by the lab. Even the proofs are CDA'd [computer density adjusted] so the client sees what they are going to get.'

01 Even the awkward array of colours, light and depth of field were easily controlled in this shot.

02 New shoes? Every aspect of a wedding can be important to those taking part. Capture it and you at least have a possibility of making a sale. If you are shooting as a complete package, then the more complete it is, the better.

03 If you 'let rip and just keep shooting', you'll get shots that simply wouldn't have been noticed, let alone captured using a tripod and fixed camera position.

04 & **05** Same wedding, radically different treatments. Kevin mixes the contemporary, relaxed style with a more formal, straightforward portraiture when the client, the location and the occasion demand. Flexibility is the key to digital photography.

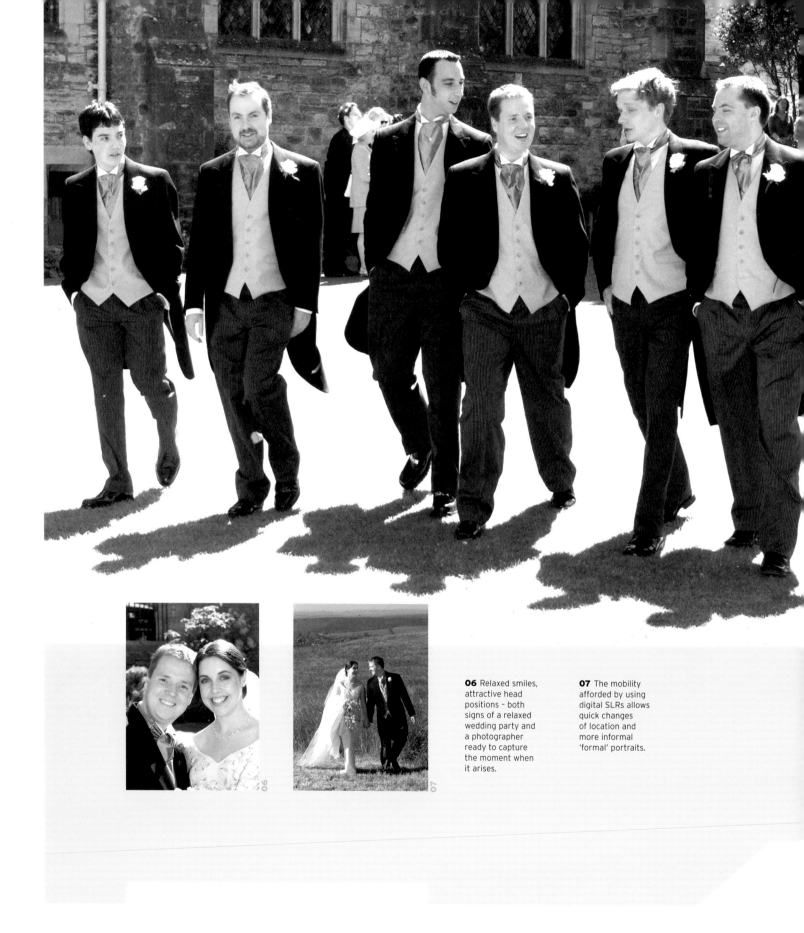

06 Relaxed smiles, attractive head positions – both signs of a relaxed wedding party and a photographer ready to capture the moment when it arises.

07 The mobility afforded by using digital SLRs allows quick changes of location and more informal 'formal' portraits.

08

09

08 'Let's go to work.' This group portrait has made the most of the new digital SLRs' abilities to deal with lighting of all types. The image was then output in black and white for maximum effect in terms of the group's clothes.

09 Behind-the-scenes pictures are much more of a possibility when you don't need to worry about how many pictures you are taking... or rather how much it will cost to get them developed.

GENERATING BUSINESS

Kevin has found placing shots on the website to be a useful tool, if not directly a sales generator. 'I'm not getting a lot of hits, but I am getting 3–4 wedding enquiries a week from [the website]. More importantly what I'm doing is that when people phone up for a price list, I send them to the website, and I'm getting a huge amount of conversion from that. Additionally I have links from both the BIPP and MPA websites to my own website, so I do get some business that way.'

DRAWBACKS

So is digital the answer to everything? Not quite. 'Not everyone wants the new look and some clients prefer just to have formal, posed shots where the digital advantage is much reduced. I also feel that digital has made photographers a bit more sloppy. The other thing is that it also lets many more people into the market. It means that anyone can go out and take hundreds of shots at a wedding and call themselves a professional wedding photographer.'

That may be true, but the key to success is being able to provide what people want, and from the size of Kevin's trophy cabinet, he certainly seems to be achieving that.

BUILDING A SYSTEM

THE EMERGENCE OF DIGITAL IMAGING HAS MADE THE PROCESS FROM PRESSING THE SHUTTER BUTTON TO ARCHIVING THE IMAGE A FAR MORE COMPLEX AND INVOLVED ONE. THIS OVERVIEW OF THE EQUIPMENT AND THE PROCESSES FROM EXPOSURE TO ARCHIVE ATTEMPTS TO ENCAPSULATE THE IMPORTANT ISSUES AND CHOICES THAT DIGITAL IMAGING NOW OFFERS.

With both digital imaging and traditional film photography, before you even load the film in the camera, you choose what output medium you want. In so doing, you determine what film type you want, and how it is to be processed. With digital imaging there are two very good reasons for thinking backwards: quality and time. You need to input enough data to get a high-enough quality image, but not so much that you will have to get rid of some at the end of the process. Input too much data and you simply make every operation you perform on an image that much slower.

AUTO-CORRECTION

The software that comes with scanners is very sophisticated. If you want it to, the scanner can remove dust spots and blemishes, and usually this works adequately. It is worth running a few scans from different film types through the scanner with the image correction on and off (and getting them printed) before deciding whether to use auto-correction.

CAMERA SET-UP

One of the main differences between film and digital photography is that where underexposure is the main concern with film, overexposure is the danger with digital cameras. While it is true that you can increase or reduce contrast with digital images, you can only play with the information that you have. By adjusting a digital image, you will be throwing some detail away. However, before you need worry about that aspect, there are four main factors to consider about how you set your camera up. They are: compression, resolution, white balance and sensitivity.

Compression

Digital files can be saved in one of three formats depending on the model of camera that you have: RAW, JPEG and TIFF. The first is the camera's proprietary format, which records all aspects of the shooting data, and contains as much colour and detail information as the camera can provide. Its downside is that it needs to be converted into a form that the software on the computer can read, and cannot be directly printed or used by anyone who does not have the right camera driver software. The files are also relatively large.

The JPEG format compresses images by a computer algorithm that examines the image and simplifies it by throwing up to nine-tenths of the file size away. This means you get many more images onto a memory card, but if you are creating large blow-ups, the image may appear blocky.

01 The better scanners include a dust and stain remover alongside their driver software. These allow images to be captured cleanly without losing detail or colour information, and ultimately produce blemish-free images such as this one.

02 This scanned image had a file size of just 6Mb when Stuart Bebb sent it in for publication, and yet it was capable of giving a 9x6 printed image with a resolution of 300 pixels per inch. What made this possible is compression.

03 Choose the largest 'optical' (i.e. genuine uninterpolated) resolution possible when shooting or scanning. It is relatively simple to reduce the size of an image (as here), but trying to interpolate an image's size upwards will not give you or your clients a great result.

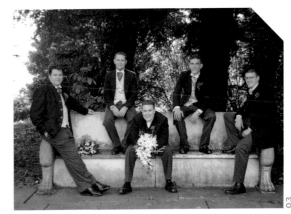

The TIFF format can be read by most scanning and image-editing programs such as Photoshop and generally works well for the printing and on-screen display of photographic images. TIFF files contain a great deal of data and are very large. However, TIFF files can be reduced in size by something called the LZW compression scheme, which some programs offer as an option. This form of compression maintains image quality while reducing the size of the file through what is known as a 'lossless' process.

Resolution

As well as levels of compression, there are levels of resolution – the number of pixels that will form your image. Choose the largest 'optical' resolution possible. This won't necessarily be the highest resolution available, but anything that gives you more pixels than there are on the sensor is using interpolation, and it will only slow you down without actually adding any detail.

White balance

Unlike film cameras, you don't need filtration when shooting with lighting other than daylight or flash. Most cameras have white balance settings for tungsten, fluorescent, flash, daylight and automatic. Some cameras also have a custom light balance setting for tricky, but constant, lighting. You can also set white balance by means of a grey card, although doing this for every shot can be time-consuming, and in the case of candid shots, may be pointless, unless you are sure both you and the subject are being illuminated by the same light.

Sensitivity

Light levels obviously vary from scene to scene, and one of the useful aspects of digital cameras is that you can change film speed with every shot, if you wish. A word of warning, though. What changing the 'film' speed does is use increased amplification of the same signal as normal film speed. Any imperfections in the digital aspect of the image will be magnified too, and give you, much like film grain, a coarser-looking image containing some rogue, coloured pixels.

MANIPULATION

When you get an image onto your computer, you may well wish to perform a number of different tasks to make it look better. Some of these are unique to digital imaging, others not. Probably the first thing you will need to do is to decide if the framing and orientation of your image is right. Levelling horizons and cropping out extraneous detail can both be done in Adobe Photoshop. Remember, though, that the more you crop from your image, the fewer pixels are left, and you will have to decide whether to use a smaller image, or take a risk of using less than 300ppi as your output resolution.

04 This Karen Parker shot shows the cleanness of digital when it comes to colour, if shot in a controlled studio situation with lights of known and (relatively) unvarying colour temperature.

04

SCANNING SETTINGS

When scanning in images from film, you need to scan them at sufficiently high resolution to produce the output required. However, until the client makes a choice about which images they want to have blown up, you have to make an educated guess about what they will want. For single images in a traditional album, your maximum output size will be around 10 inches on the longer dimension. As we need to have images with a physical size of 10 inches with a resolution of 300 pixels per inch that means you need to scan in 10x300 (3000) pixels on the longer side of the image. With 6x6 on 120 film that means a scanning input resolution of 3000/2.2 (3000 pixels divided by the number of inches in the image width of 56mm). This gives an input resolution of 3000/2.2, about 1350 pixels per inch. For 35mm scans it is 3000/1.4 i.e. 2150 pixels per inch to get a print of 10 inches wide at 300ppi from the long side of the negative. If your client wants a 30x20-inch print, you need more input resolution (see table) but images of this size will be few and far between, so there's no point in scanning in dozens of images at huge resolutions when you don't need to. Remember, though, that you can crop an image at the scanning stage, and you need to have 3000 pixels on the long side, so if you are only using a portion of the negative, you will have to increase the scanning resolution accordingly.

Fast scanning
High resolution scanners are not as slow as they used to be. However, unless you want to spend large amounts of time clicking on individual OK buttons, buy a scanner that allows batch processing. Scanners are not as expensive as they were, but, as with all aspects of photographic equipment, you eventually get what you pay for, so buy the best model you can afford.

SHARPENING

Sharpening is a feature unique to digital imaging. An analogy for how it works is to imagine the difference between a group of people clapping, then imagine how different it would sound if they all clapped in unison. Sharpening uses a sophisticated algorithm to make the edges of definable detail more obvious, making those elements that are sharp, sharper.

Used in moderation, sharpening is very useful for bringing out edge definition and emphasising specific details (you can apply it on a local level by selecting an area to sharpen), or for making a whole image look sharper. But it can easily be overdone, in which case all colour subtlety is lost and the image looks artificial.

BLURRING

This is effectively the opposite operation to sharpening, but it can be used for the same purpose. By de-emphasising a messy background, it serves to emphasise the perceived sharpness of those unblurred elements. This again is best done selectively, and is best performed in a series of slight blurring operations with the selected area shrinking slightly as you perform each operation.

PRINT LENGTH IN INCHES	PIXELS NEEDED	35mm SCAN RESOLUTION	6x6 SCAN RESOLUTION
6	1800	1300ppi	815ppi
8	2400	1740ppi	1090ppi
10	3000	2175ppi	1360ppi
12	3600	2600ppi	1630ppi
16	4800	3500ppi	2180ppi
20	6000	4350ppi*	2720ppi
30	9000	6525ppi*	5440ppi*

* 4000ppi is the highest optical resolution most scanners have. Anything above that and the scanners interpolate the extra pixels. This means they look at two pixels, decide what colour should be between the two and put that value in. In other words, it is guesswork, not information from the negative. You are better off scanning in at 4000ppi and rescaling the image yourself in Photoshop. Finally, if you want the length shown in the left-hand column to refer to the short side rather than the long side of the image, then you need to multiply the figures in the 35mm column by 1.5, and to get the short side figures for 6x4.5, multiply the 6x6 column figures by 1.333.

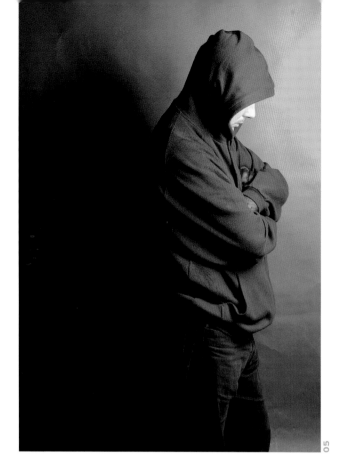

COLOUR CORRECTING

Although auto white balance is by and large pretty good, you might want to make some adjustments to the image in colour terms. It might be that the subjects have picked up a colour cast from light reflecting off a brightly coloured surface near them. This is normally a two-click operation and, as it is performed in real time on your monitor, you can keep making minor adjustments until it looks right.

REMOVING BLEMISHES

Using the cloning tool in Photoshop allows you to cover up small blemishes or artefacts by copying from an adjacent area. This is best done last of all so the boundaries of where you have copied are not emphasised by any other operations.

05 You can correct for colour casts, or you can accentuate and manipulate them to get the effect that best matches the image and the portraiture client, as shown by Karen Parker's moodily lit study.

06 You don't always have to apply an effect to the whole of an image. By means of careful selection using Adobe Photoshop's lasso and other tools, you can apply effects only to the foreground subjects or, as in this case, only the background.

SAVING AND ARCHIVING

For sophisticated manipulations, you should make sure you save the file at different stages and possibly with different names, so if something doesn't work out, you can come back to it later. A specific example of this is when you are making copies of the same image in colour, monochrome and, say, sepia. By performing all the other manipulations you want first, you can change the colour mode last rather than having to repeat any fiddly retouching, sharpening or blurring on each different-coloured image.

Save the file as a Photoshop file (PSD format) as that will be the quickest to reopen. Final files should be saved as TIFFs, and perhaps lower-resolution copies saved as JPEGs for web use or proofing CD-ROMs.

Make sure you give your files meaningful names, and also place them in a folder on your PC and on a CD-ROM with the client's name in the folder title.

07 Once you've captured, deblemished, sharpened, blurred and otherwise manipulated your image, you need to make a final saved copy for archiving purposes, probably as a TIFF, as with this Karen Parker shot. But whenever using Photoshop, you need also to have made a series of saved copies along the way. Not only will this allow you to pick up where you left off if your computer crashes, it allows you to go off in different directions with the image without losing the ability to pick up at any point. Look after your creation. Once a shot is lost, it is lost for good.

The computer

SOME PEOPLE ARE STILL AFRAID OF COMPUTERS. VIRUSES,
SYSTEM FAILURES, THE THING SIMPLY NOT WORKING FOR NO
REASON, ARE FEARS FELT MOST KEENLY BY THOSE WHO
KNOW LEAST ABOUT COMPUTERS.

Fear of the unknown is simply human nature, and the best cure is
knowledge. Ask anyone who uses computers specifically for digital
imaging, and they will confirm that things do go wrong, but for
99 per cent of the time, computers are invaluable tools. Simply
being aware of their vulnerability to failure and learning more
about how computers work are good starting points for
approaching these machines.

BEST BUY?

The first question is which kind of computer should you buy?
The easy answer is that you should get the fastest machine with
the greatest capacity in terms of hard disk space, memory,
graphics capability and connectivity that you can afford. The next
question is whether to buy a PC, which runs Microsoft Windows,
or a Macintosh, which runs Apple's operating system.

If you poll 50 people involved in digital imaging, all those who
own Macs will tell you very earnestly to buy a Mac, and all those
who own a PC will tell you very emphatically that PCs are
infinitely better. There's no such thing as an impartial opinion,
and you won't find one here. It's a personal view, but Macs are a
perfect introduction for those who are afraid of computers. Macs
are also the computer of choice for those working in the fields of
graphics, image editing and design.

You will often see computers advertised as having the fastest
processor on the market. They will have chip speeds of more than
2 gigahertz. This means the chip's internal clock pulses more than
two billion times a second, but this is not the end of the story.
Because of the way chips work, some processors with slower
clock, or chip, speeds have larger instruction sets and can actually
perform more calculations per second than those with faster
clock speeds. For this reason you will often see Macs with a
specification that includes a slower clock speed than a PC, yet will
be faster when running Photoshop.

It's almost impossible to advise specifically on the minimum
clock speed, hard disk size, memory, let alone on the more
abstruse factors like backside cache and video memory.
Specifications are always changing, the technology doesn't stop
advancing, and suppliers are constantly offering different deals –
one of which may be suitable for you.

Stylish PCs
If your studio is
going to be visited
by clients and you
wish to incorporate
the digital nature of
your work into a
demonstration,
make sure your PC
looks the part. It
may be a small
thing, but it all
works to create the
proper impression.

COST BENEFITS

Essentially, you should spend as much as you can on your computer. If you cost out your time, and work out your hourly revenue generation, you will quickly see that a computer with a higher, all-round specification (i.e. one where you don't spend hours looking at the screen waiting for something to happen) is more likely to produce cost benefits than a cheaper model. With digital imaging you spend long enough in front of a screen as it is – don't make it worse by going for the false economy.

Separates
Computers tend to come in three bits: the main processor unit (which contains all the clever stuff), the monitor, and the keyboard/mouse. Buy cheaply on any of the three and you will eventually pay the price in terms of usability.

Big Mac
This book was written and designed on Apple Macs. There are many good reasons why a huge percentage of people in the creative media use Apple Macs. They are easier to set up and use, the desktop is easier to customise and is more intuitive, they are more stable, and are easier to fix if they do go wrong.

Software

ONCE YOU HAVE A COMPUTER THERE ARE AN IMMENSE NUMBER OF ACTIVITIES
THAT YOU CAN USE IT FOR: WRITING LETTERS, DOING ACCOUNTS, USING THE
INTERNET, SENDING AND RECEIVING EMAIL AND SETTING UP YOUR OWN WEBSITE.

Image editing is the main activity that a professional
photographer will carry out using a computer, and there is one
program that you need to do it – Adobe Photoshop. There are
other (sometimes significantly) cheaper pieces of software that
can carry out some of the functions available in Photoshop, but
none that has every function, and none that performs as well.

IMPORTING
Digital images are imported into the computer via a scanner or
a digital camera. An image is imported via a scanner simply by
placing it on it and running the appropriate software on your
computer. There are several ways in which images are imported
from a digital camera into a computer. The camera's card can be
slotted into a compatible card reader which plugs into the USB
or Firewire port on the computer. Alternatively the camera
can usually be plugged directly into the PC via a USB or
Firewire cable.

VIEWING
Once you open the image in Photoshop, you can view it at full-
frame size or zoom in on particular areas. The former is useful

for deciding whether colour changes or cropping are needed,
the latter for identifying and correcting blemishes or areas that
need sharpening or blurring.

CROPPING
Cropping at the start of the creative process creates a better
image and a smaller file. With the sliding crop box you can
adjust the crop or the rotation of the image at will.

CORRECTING
Your next step is to colour correct the image. Photoshop is
capable of doing this automatically or you can colour correct
manually. Similarly, the contrast can be adjusted either
automatically or manually.

REPAIRING
Photoshop has several tools for repairing damaged images,
or merely covering up unwanted specks of detail. You can also
remove skin blemishes, whiten teeth, tidy up hair and remove
stains from wedding dresses, providing, of course, that you're
prepared to invest the time.

RESIZING

Once you've made all the changes that are needed to an image, you can adjust the image to the preferred physical dimensions and resolution before saving it in one, or more, of the many formats that are available in Photoshop.

OTHER USEFUL SOFTWARE

As well as Photoshop, it might be worth having one or two cheaper ancillary programs as well. One activity for which Photoshop isn't ideal is creating panoramic shots from a series of single images. There are commercially available pieces of software that are more suitable for this; they may even be supplied free when you buy a printer or scanner. The benefit of creating panoramas from single images is that you get four times the resolution compared to shooting the whole scene with a wide-angle lens.

King of the hill
The ubiquity of Adobe's image manipulation program is evidenced by the fact that it is the only software title to have been turned into a verb, as in 'to photoshop an image'.

01 It is very rare that a shot needs no tweaking whatsoever. Even the most straight-forward of shots (like this studio shot by Ian Cartwright) can be improved when it is pulled into Adobe Photoshop.

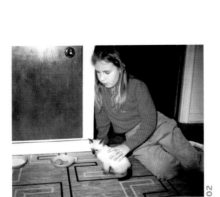

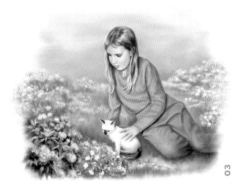

02 & **03** This set of before and after pictures from Helen Yancy neatly encapsulates the possibilities of digital imaging. To be able to perform transformations of this kind takes time, the right tools and software (Adobe Photoshop and Corel Painter) and not a little artistic ability and experience. But remember that every hour that you spend in front of your computer monitor is an hour you are not getting new clients, taking pictures or selling repeat orders from a previous shoot. If yours is a turnover rather than a premium-based business, you may not be able to afford to perform manipulations as complex as this.

The monitor

THE MONITOR IS THE MOST HEAVILY USED OUTPUT
DEVICE ON A COMPUTER. THE DISPLAY PROVIDES
INSTANT FEEDBACK ON THE EDITING OF YOUR IMAGES
AS YOU WORK ON THEM.

Colour calibration
A high-end CRT screen

Flat screen
A Trinitron monitor

Most desktop monitors use a cathode ray tube (CRT), while portable computers use flat panel displays, usually based on liquid crystal display (LCD) technology and have a smaller energy consumption. CRT technology requires a certain distance between the gun that fires the electron beam and the screen, which makes these monitors very bulky. CRTs consume about 110 watts for a typical display and account for more than 80 per cent of the electricity used by the whole system.

An LCD monitor will cost more to buy, but is cheaper to run. As flat-panel displays continue to increase in size, improve in resolution and become more affordable, they will gradually replace CRT monitors. But at the moment, a high-quality 19-21-inch CRT monitor is probably the best combination of value and performance.

VIEWABLE AREA
Screen sizes are normally measured in inches diagonally from corner to corner. Because the listed size is measured from the inside bevelled edges of the display casing, make sure you ask what the viewable screen size is, which will be measurably less than the stated screen size. Popular screen sizes are 15, 17, 19 and 21 inches. The size of the display will directly affect resolution. The same pixel resolution will be sharper on a smaller monitor and fuzzier on a larger monitor because the same number of pixels is being spread out over a larger number of inches.

MAXIMUM RESOLUTION
Resolution refers to the number of individual dots of colour, or pixels, contained on a display, and is expressed by the number of pixels on the horizontal axis and the number on the vertical axis, such as 640x480. The monitor's viewable area, refresh rate and dot pitch all directly affect the maximum resolution a monitor can display. You will often see reference to 'dot pitch'. This is the measure of how much space there is between a display's pixels, and with dot pitch, smaller is better. The closer together the pixels, the higher the possible resolution.

REFRESH RATE
In CRT monitors, the refresh rate is the number of times that the image on the display is drawn each second. A refresh rate of 72 Hertz (Hz) means that all the pixels from top to bottom are refreshed 72 times a second. Refresh rates control flicker, and you

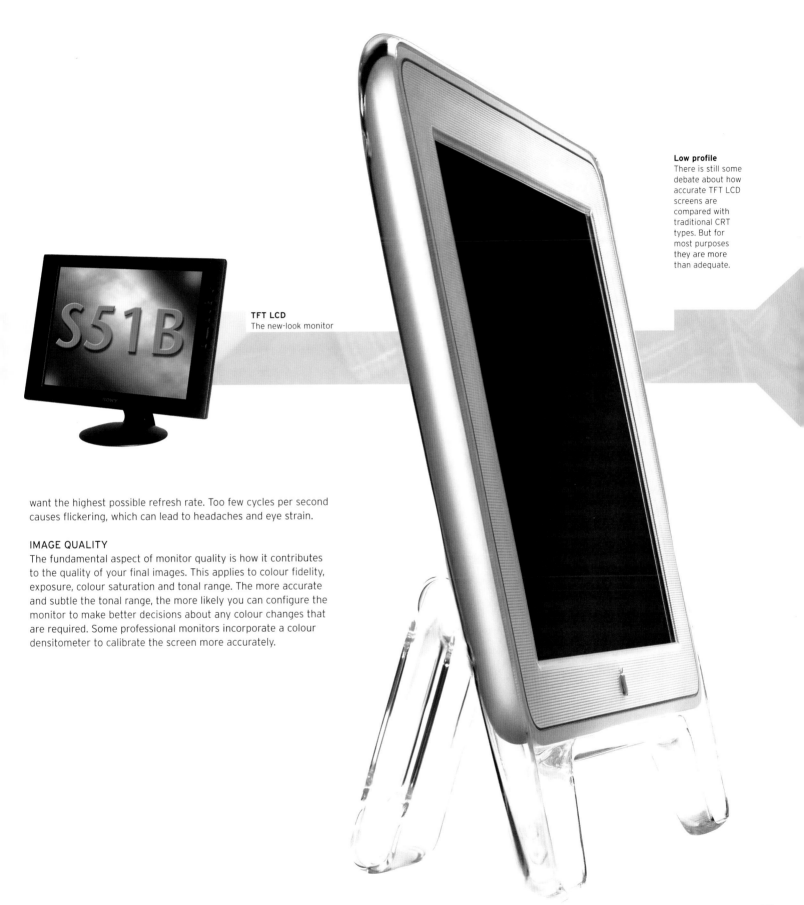

Low profile
There is still some debate about how accurate TFT LCD screens are compared with traditional CRT types. But for most purposes they are more than adequate.

TFT LCD
The new-look monitor

want the highest possible refresh rate. Too few cycles per second causes flickering, which can lead to headaches and eye strain.

IMAGE QUALITY

The fundamental aspect of monitor quality is how it contributes to the quality of your final images. This applies to colour fidelity, exposure, colour saturation and tonal range. The more accurate and subtle the tonal range, the more likely you can configure the monitor to make better decisions about any colour changes that are required. Some professional monitors incorporate a colour densitometer to calibrate the screen more accurately.

PAUL YAFFÉ
'Today you can't compartmentalise people...'

Paul Yaffé started his photography career in his father's GP studio in Manchester. His idol was Desmond Groves and he only wanted to do portraiture. So when he followed his fiancée's move to Southport, he set up his own studio. This grew to an organisation employing thirty-two staff, including a lab with printer Mike Anderton FBIPP and photographic artists also qualified by the BIPP. Since the advent of digital this has fallen to a staff of twenty-two.

'As a photographer, you can't just imagine you're in a different type of business than everyone else's', says the shrewd businessman and true gentleman-photographer Paul Yaffé.

QUALITY ISSUES
'Everything in business revolves around economics and, when we were looking at ways to be more profitable as a company, different aspects of work were also tossed around the table. That's when the topic of digitisation came up. Adam [Paul's son] was the person who decided we ought to make this jump. He was always a gadget freak – his bedroom was full of wires. He'd played with Paintshop Pro and Photoshop, realising that this was something we'd have to do one day. But the right time was a long time coming. Quality was a big issue. I was put off by a Kodak Gold Circle speaker from the US who said, "Unless you've got a triple-pass camera for still-life work, you can't enlarge more than 16x20".' Then the Philips 3kx2k CCD brought a new

dimension in image quality. Six megapixels, very low noise, huge dynamic range and superb scalability made it possible to enlarge the image much more than was thought possible. Packed inside the neat Megavision S3 back it was the studio capture solution they had been waiting for.

TIRED OF LABS
Open minded, the Yaffés didn't rush headlong into digital for the sake of it. On the contrary, when the decision was made it was based on a sound knowledge of the digital market and carefully considered business decisions backed up by many spreadsheets and 'what ifs?'.

Initially the Yaffés continued to use film for location shoots, sending the negatives out for high-quality scanning. But the quality was lower than the studio work using the Megavision S3s. 'Anyone who is looking for fine quality is going to go digital because they're going to get tired of labs giving them shoddy work. Negs would come back scratched, prints

cropped as though a child had done it, they even lost a neg for almost ten weeks.' Adam feels that pro labs don't want photographers who are particular about how their work looks. One lab actually said to him, 'Do you know Adam, I think we've sorted out the whole problem – don't send us any more work'.

COMPLETE CONTROL
Fortunately, they no longer need to. With the Nikon D1X on board they now have complete control of everything in-house. 'The Nikon D1X is slightly softer than the Megavision at 30x40 inches', says Paul, but as we usually use a Softar filter that doesn't really matter. It's lighter in weight than the Hasselblad with all the kit. The fact that it's digital doesn't make any difference, either. When one salesman-style client said, "I've got a digital camera at home and I can take pictures", I replied, "I've got a football at home but I can't play football like David Beckham".'

01 Paul Yaffé with the Nikon D1X, which he uses on location.

02 The Epson 9500 is a wide printer but its superb archival quality make it the ideal replacement for a wet darkroom.

03 Paul examines a print while using a Kodak 'Color Viewing Light Selector' to check the ambient light in the Art room. This has two magenta patches that appear the same colour if the light source is equivalent to 500K, with adequate amounts of red, green and blue light to result in a high CRI (Colour Rendering Index). Paul uses special fluorescent tubes to ensure accuracy.

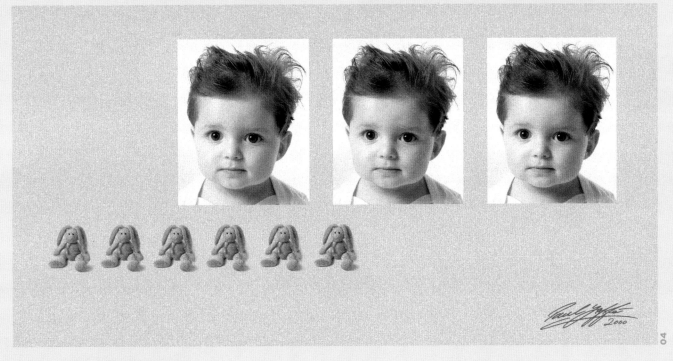

04 This is a straightforward shot that is much more than the sum of its parts. A simple studio shot repeated (along with the image of the child's toy) make this print something well out of the ordinary.

05 This shot combines two pictures from the same shoot – a full body shot and a head and shoulders shot used as a coloured background. The strong colour combination and the combination of images make the portrait a picture to be hung.

STIMULATING CREATIVITY

'I like to photograph people in a way that suits them, not necessarily in a set way', says Paul Yaffé. 'The client isn't necessarily going to be pleased because everything is posed correctly but rather because it represents them in the way that they live. Today you can't compartmentalise people as you used to be able to. People's homes are different, they dress differently, they live differently. Photographing people has little to do with photography. It's to do with personality, control, entertainment, being personable, people liking you.'

In effect, the Yaffés have used their move to digital imaging to reinvent their creative processes, stimulating themselves and their clients by exploring new directions.

CUTTING COSTS

Now the Yaffés are happy that they switched. 'Digitisation gives us a greater degree of control and reduces our material cost percentage. Inks are cheaper than chemicals, paper is cheaper than sensitised paper. Overall it's a lot less.'

Nine months later, the Kodak rep phoned to find out why the Yaffé account was zero.

06 This was a very strong image to begin with, but the treatment has once again made the difference between a strong photograph and an artwork that people would be happy to own whether they were in it or not.

07 Another combination of images. This time the leather jacket theme is picked up by the monochrome rendition. The repetition of different images gives the eye something more to digest than the single main image.

ADRIANO SCOGNAMILLO
'Digital brings many advantages'

01

Adriano Scognamillo is a photographer in Perugia, the hilltop university capital of Umbria, famous for its annual jazz festival, the largest in Italy. He ran a studio in the historic city centre for five years, before which he was based in the suburbs for fifteen years. His studio window reflects the events of the city, especially in his portraits of local people and musicians.

Adriano's first adventure into electronic imaging came in 1997 using a Mitsubishi video passport system. He noticed how clients became more involved with the picture-making process and loved seeing their poses displayed on the monitor before printing. They liked his pictures and wanted enlargements and monochrome prints, but this was not possible from the rather low-quality video capture system.

UNIQUE SYSTEM
He saw that Olympus produced a digital passport system, using a Camedia 2500 2.5 megapixel digital camera, so he made his own system. He uses a Camedia 2500 for portraits, then inserts the SmartMedia card into an Olympus P330 printer, which has video output that displays the images on a video monitor.

The P330 prints a block of four passport pictures or one larger image. Clients order large prints of the pictures they like and also bring their partners and families. The system is also popular with groups of teenagers, who like walking out with multiple copies of a photograph of themselves and their friends – instantly. Larger prints, up to 12x16 inches, are made by importing the images into the computer.

Adriano began to use the Camedia 2500 experimentally for other work. Using a wide-angle attachment, he photographed the interiors of shops for a client to use in presentations to other potential clients. This was immediately successful and more cost-effective than scanning 6x7cm transparencies.

EXPANDING THE OPTIONS
Finding digital much more convenient and predictable, and being an established Canon film SLR user, Adriano purchased a Canon D30 digital SLR. This also eliminated the hassle caused by laboratories not doing what they are asked to do.

He gives clients a CD-ROM of low-resolution proofs to view at home, if they have computers; otherwise they receive an inkjet-printed proof sheet. Clients order their prints from these proofs, without any pressure.

When he photographs musicians at the Umbria Jazz Festival, he gets great results in low-light situations using the Canon D30.

Performers look at inkjet proofs in his studio shop, final prints being produced on a digital mini-lab in a town nearby. He is considering the purchase of a Fuji Digital Frontier mini-lab of his own.

COMPETITIVE EDGE
Scognamillo says that seventy-five to eighty per cent of his work is now digital. It brings many advantages, including the ability to tailor output to clients' special needs. Some clients don't need prints at all, as their images are for use on the Internet or in printed publications. He also finds that people like the fact that they are digital because it is perceived as modern. People ask for digital and this gives his studio the competitive edge. It's very good for business.

01 Cashmere. Studio shot for a catalogue captured using the Canon D30. Just because a shoot is in the studio, it doesn't mean that digital doesn't have the advantage. In a controlled situation, the photographer can check each image as it is captured with greater accuracy and and without the cost of Polaroid prints.

02 Location wedding shoot using the Canon D30. The ability to carry a camera that can capture high-enough quality images is a key advantage of digital. In addition, as long as your memory card has sufficient capacity, there's no need for 'film changing'.

03 Saxophone player Courtney Pine captured during the 2001 Umbria Jazz Festival with the Canon D30. One of digital's great advantages is its ability to capture detail in low or complex light.

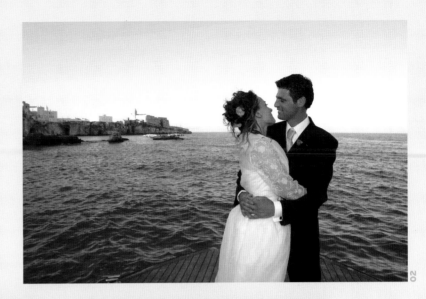

04 The David Parsons Dance Company captured in performance using the Canon D30. Using an SLR that accepts a range of lenses from 16mm to 500mm means you can shoot from wherever the subject needs.

05 & **06** Studio portraits made using the Canon D30. With digital the photographer has complete control over softness, sharpness, cropping and colour saturation.

07 Reproduction of an eighteenth-century map by Abraham Ortelius for a book, made using the Canon D30. Actual size is approximately 16x24 inches.

CLIENT OBJECTIONS

INTRODUCING ANYTHING TO THE CLIENT OTHER THAN THE FINISHED IMAGES COULD PROVE TO BE COUNTER-PRODUCTIVE – YOU MAY FIND YOURSELF TRYING TO OVERCOME CLIENT OBJECTIONS THAT YOU HAVE UNWITTINGLY PLACED IN THEIR MINDS.

Clients view the production of a perfect portrait as a two-stage process: you take the picture and you give them the picture. They won't really care how or what you do – only that the photographs appear at the agreed time and price, and that they are of an acceptable quality. If you have a client who shows an intrusive interest in the digital process, steer the conversation round to their pictures either in the studio or on their wedding day.

TAKING CONTROL

Clients want you to make them look good, or at worst like themselves. They want you to be in control without being authoritarian. At weddings they may want some crowd control too. Although you may want to discuss lighting with someone getting married after 4pm in midwinter, clients generally do not want to discuss the relative merits of film and digital.

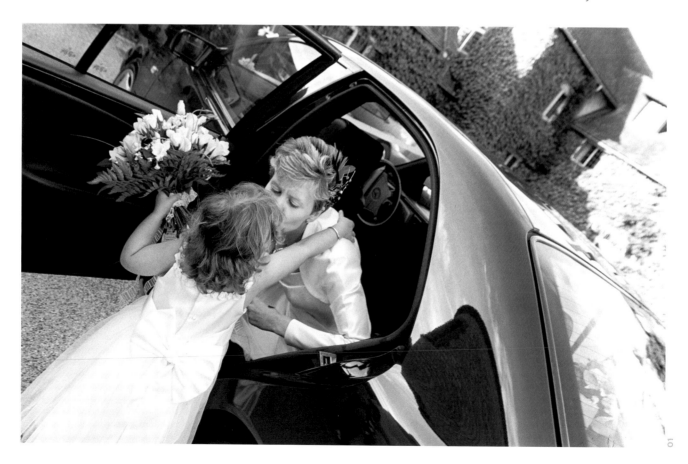

01 Digital manipulation of images isn't necessarily about wacky and weird interpretations. This touching shot merely needed to be treated in a manner suitable for the subject.

02 & **03** Variations on the theme of multiple imagery. The 'toned' shot uses three crops of the same image to give a dreamlike feel to the final picture. In the colour shot, different images are used to make the most of the location and give the clients the feeling they are getting three for the price of one.

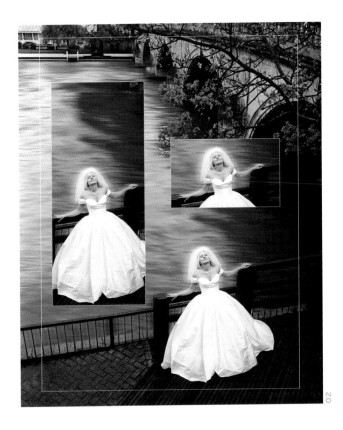

DEMONSTRATING YOUR SKILLS

Just as magicians never show how their tricks are done, you should make no attempt to demystify the photographic process, or worse, tell of any digital obstacles you have had to overcome for other clients. You might be tempted to have a dig at another photographer by belittling the application of one technology or another, but this will only backfire.

If you are explicitly asked, particularly over the phone, which camera you use to take pictures, then you must not, of course, lie. And there is a risk, as demonstrated in one of our case studies, that if you tell people you use digital photography, they may not want to proceed. But it is all a case of managing objections rather than looking for them.

You can demonstrate the quality of your work by having your photographs on the walls of your studio, or having framed prints lying around as if they're just about to be delivered to clients. This can have the additional benefit of silently suggesting to clients that they too might want to buy similarly framed prints.

Be prepared to explain, but keep the discussion related to the commission in hand.

Which is which?

THERE WILL INEVITABLY BE SOME OVERLAP IN YOUR WORK
WHEN CHANGING FROM ANALOGUE TO DIGITAL. DURING THIS
PROCESS IT IS IMPORTANT THAT THE CLIENT ISN'T
DISTURBED BY SEEING IMAGES FROM BOTH METHODS.

One of the most difficult ways to make the transition from
analogue to digital is to run both alongside one another because
there is likely to be a visible difference between results. This
difference can be lessened if you do not mix the output media.
There's far more of a difference between a photographic print and
an inkjet print than there is between an analogue picture and a
digital picture printed onto the same media.

CONTROLLING OUTPUT

If you use both inkjet and silver halide prints, it is worth
abandoning one and using the other for all your images, certainly
as far as your presentations are concerned. Alternatively, it might
be sensible to use inkjet prints only for very large or non-standard-
sized images. This is because if you have a client that has chosen
the inferior print for reasons of price, they are likely to feel that
they are receiving an inferior product after seeing the better
print. This is unlikely to encourage repeat business and will
make the client feel inadequate because they cannot afford
the superior product.

CLIENTS WANT RESULTS...

If you do use mixed output media, then do not differentiate
between digital and analogue (or silver halide and inkjet) when
showing pictures to clients. If they see a difference, it's because
your system isn't correctly colour managed, or because you may
have heavily manipulated a given image. If they do not notice a
difference, they do not need to know which shot was taken with
which camera - the clients do not need to know about the
technology, only the results. It might be nice to get a pat on the
back for a brilliant piece of work in Photoshop, but the harder you
have to work to produce a result, the smaller the amount of
confidence you will generate in yourself as a photographer.

...BUT NOT TEST RESULTS

Clients do not need to know that your studio lighting is set up so
an idiot can shoot well-lit portraits; they need only know that you
can produce excellent portraiture with the minimum of fuss. When
showing potential clients the results of previous shoots, never
show works in progress, particularly rough proofs you may have
done on an inkjet printer. In addition, any tests that you have done,
whether for exposure, metering, depth of field or colour
management are for your reference only. They do not need to be
shown to the client to demonstrate how poor your initial results
may have been, or how heroically you have managed to tame the
vast resources of digital imaging. The client's peace of mind comes
from having a professional photographer.

01 Although it is possible to preview images for clients in the studio, you shouldn't really show results when you have a manipulation in mind - i.e. when the shot itself is only the beginning of the process.

02 Although you can produce portraits in minutes with the right equipment, this should only be done when the client has specifically requested it. Otherwise you may make a single sale when a return visit would have netted more than one.

03 The trust that a client places in you should be reinforced by the final result, not established by it. By hanging work in your studio (like the three Karen Parker shots on these pages) you can demonstrate what is possible, and even get the client to suggest trying different poses, or better still, multiple portraits.

03

Pixels

WITH FILM PHOTOGRAPHY, FEW PHOTOGRAPHERS CONCERN THEMSELVES AT THE MOLECULAR LEVEL WITH THE CHEMICALS THEY USE. BUT WITH DIGITAL PHOTOGRAPHY, IT PAYS TO KNOW WHAT'S DOWN THERE, DEEP INSIDE.

In traditional photography the choice of film stock is at least as important in achieving a desired image as the camera. In digital photography the film is the camera - what you buy is what you live with. And as it's computer technology that has combined the roles of film and camera, digital cameras are now really more a computer than an optical device. This means that even experienced photographers need some knowledge of new technologies to exploit the digital camera's full capability.

CCD
The heart of a digital camera is the semiconductor chip called a charge-coupled device (CCD). When the shutter opens and light strikes the CCD, temporary electronic changes to pixels on the CCD are converted into computer language and recorded on either internal or removable memory. The greater the physical size of the CCD and the more pixels it contains, the better the quality of the image. The standard CCD is considerably smaller than a frame of 35mm film, and at present it appears to be stuck at that size. However, more and more pixels are being crammed onto the CCD chip every year.

PIXELS AND MEGAPIXELS
Pixels, and their multiple - megapixels (one million pixels) - directly determine how detailed and rich an image will be. They also decide how much the image can be enlarged and still be found acceptable. To recap, a pixel (PICture ELement) is the smallest building block of a digital image. Each pixel is numerically assigned a representative colour, and, like an intricate mosaic, each pixel becomes a tiny, integral part of the larger image.

FILM EQUIVALENT
When trying to work out what the equivalent pixel count of film would be, estimates range from 6.5 million to 10 million pixels, although there are further variables involved including the type of film and the quality of the optics used to produce the image. Currently, the highest resolution available commercially is a little more than 6 megapixels. Although this is beginning to approach the lowest estimates for the resolution of film, for most purposes, it is sufficiently close.

01 & **02** The question as to whether digital is good enough is answered in this shot from Karen Parker's Lightphase digital back. The quality – even on this large sectional enlargement – shines through.

Archival permanence

IN THE EUPHORIA OF RECEIVING A SET OF PRINTS OF A
WEDDING, OR A RANGE OF PORTRAIT SHOTS, THE CLIENT
MAY NOT HAVE THE LONGEVITY OF THE IMAGES AT THE
FOREFRONT OF THEIR MIND. HOWEVER, THIS ISSUE IS AN
IMPORTANT ONE FOR ANY PHOTOGRAPHER.

It may not be a question you have been asked very often by
traditional clients, but after the switch to digital, you may be
asked how long images will last. If you are printing onto
traditional colour paper, the answer is 'as long as any photograph
will last'. However, if you are printing onto inkjet paper, the answer
is not quite as simple.

INK IMPROVEMENTS

The quality of the ink is a crucial factor. There are two kinds of
ink: dye-based and pigment-based. Depending on their
formulation, the former can fade over time on exposure to light,
but the latter are less susceptible to light exposure. Many tests
have been carried out over the years to assess how long
photographic images should last, and the fact that we can still
look at images from the dawn of photography proves that silver
halide is a technology that works. With inkjet printing, the primary
aim of printer and ink manufacturers was first to ensure that
images printed and dried quickly, reflecting the office-based
environment in which the medium is principally used. As the
technology became used more and more in the printing of
images, new developments had to take place if the life-
expectancy of an inkjet-generated image was to match
that of a silver-halide print.

ENVIRONMENTAL CONSIDERATIONS

If you are selling photographs, then no matter how satisfied your
clients are when they first buy them, that satisfaction will
evaporate if the images fade after only a few years. There is an
obligation to ensure that all possible measures are taken to
ensure that only archivally permanent images are sold. Another
aspect to consider, and on which it might be useful to advise
clients, is that of the display environment. Prints should always
be matted using archival materials and framed behind glass.
Exposure to high humidity, air pollutants and daylight can also
reduce the life of a print.

PRESERVING THE FILES

The other aspect of archival permanence is that of the digital
data in its raw form. Saving images once onto your PC's hard
disk is not permanent, as anyone who has had a disk failure
knows. CD-ROMs are a good back-up solution, but it is also a
good idea to have other back-ups, preferably stored off-site, as
well. The files you will want to save are the finished image, and
when you have been capturing files in RAW format, those files
also need to be archived.

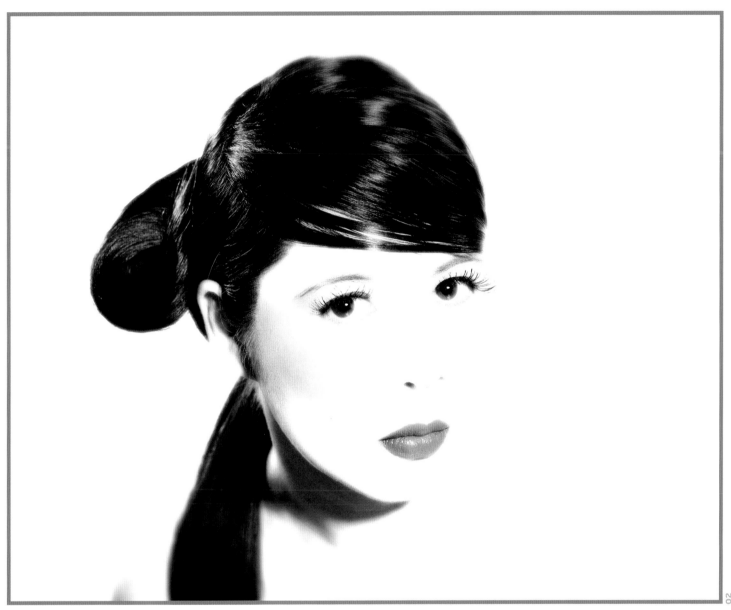

01 In the Yaffé Studios art room, Adam Yaffé looks on as his assistant Catherine removes a print from the Epson 9500 printer.

02 It is vitally important that you choose inks and papers that go together when producing prints in-house with an inkjet system. It is not merely the question of archival permanence, but also that of repeatability. From session to session and from week to week, the results need to be consistent or subtle images, like this Paul Yaffé Studios shot, could have unwanted and even unpleasant hues introduced.

KAREN PARKER
'Digital gives more options to the customers'

Karen Parker may have been a professional photographer for only three years, but you wouldn't know it from her confidence. Shy, retiring, uncertain, frightened of new challenges. None of these epithets can be applied to her. 'I'd been in this business five minutes and I knew that digital was the only way to go', she states. 'Digital is photographic Viagra.'

Karen got into professional photography three years ago. 'I did a BTEC HNC in a year. I was lucky to get a place at college as I'd had no previous training. All I had at the interview was a couple of tearsheets from an amateur photo mag that had published some of my pictures.'

LAUNCHING A STUDIO
'There was an ad in the Evening Standard for a house with commercial premises.

We phoned up and it turned out it was a photographic studio – so I decided to start a portrait studio. With the last of my money I bought an Apple Mac and a scanner. I was shooting with a Bronica GS-1 onto negative film. I started off by shooting the public in portraits and then, within two months, because the social market was undervalued, I went for commercial work. Initially I was getting about 80:20 commercial:social but it's

now it's moved to 50:50.' Within three months of setting up her studio, Karen had won a Kodak Gold award, and a year later she was Agfa UK's Digital Photographer of the Year. This success is in no small measure due to her positive view of things. 'Photographers always consider the worst-case scenario when they should be thinking of the best-case scenario.'

'SALES ARE EASY'
Karen now works with a Mamiya 645 and a PhaseOne Lightphase H10 digital back providing 8x10 prints at 300ppi (18Mb) or indeed up to 16x12 or 20x16 with interpolation onto photographic paper.

'The nicest thing, for people who are wary, is that as soon as the shot has been taken they can see their image on a monitor. As long as I keep them continuously editing what they're viewing, it's good for sales. Because it's so easy for them to see a good shot, I find sales are easy. What I say to customers is "If you like a picture you will never ever change your mind about it".'

'At the moment the printing is done at a professional lab who pick up a CD from me every two days. I'm not one of those people who'd give someone an inkjet though,' she says 'I don't think it does the job.'

01 Digital capture allows fine control over tone and cropping both at the moment of capture and also afterwards when the image is being prepared for output.

02 Although not strictly a digital tool, Karen puts her younger subjects at ease by having a couple of ferrets running around in her studio.

03 By using a digital system, hue and saturation can be fine-tuned to make the most of the image captured in the studio.

100 PER CENT DIGITAL

So what is her overall view of digital then? 'I've been 100 per cent digital for two and a half years and the website has been up two years. But I haven't been doing it that long and I still feel I'm a student half of the time. I would say digital gives more options to the customers and when I can show a shot and show it in duotone or monochrome the clients get really excited.' You get the impression that the clients are not the only ones.

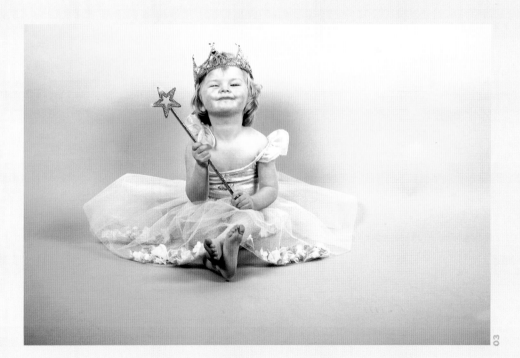

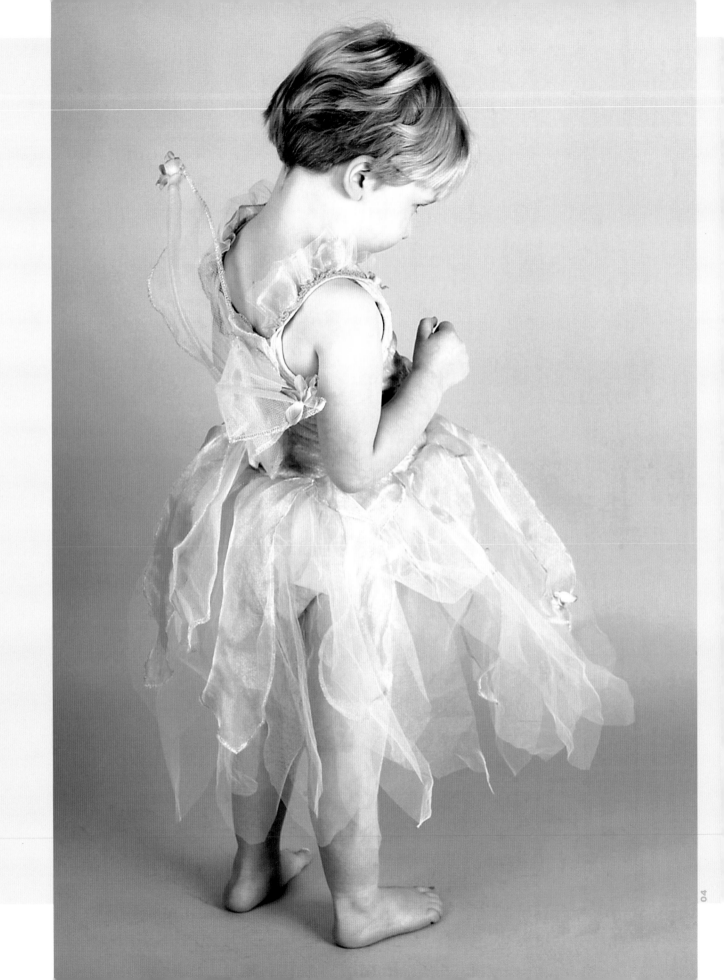

04 This voile fairy costume was a huge test of the resolution capabilities of the camera and lens outfit that Karen Parker uses.

05 The tonal control required to get this shot right is very exacting of any camera/capture system. The smoke, facial tones and black background are all perfectly rendered.

06 An in-your-face portrait of a different kind. Karen will sometimes show her clients the images as she goes along. As she says, 'If you like a picture you will never ever change your mind about it'.

07 The ability to shoot quickly, and without needing to change films is a great boon when the fleeting expressions of children are involved.

08 This BIPP award-winning shot shows both what can be resolved with the digital system and also the level of detail that clients may or may not want in a standard portrait shoot.

ELIOT KHUNER
'Digital allows you to work more and make less money!'

Eliot Khuner has been around for a fair old time. He shot his first wedding in 1978 having started as a studio photographer under the tutelage of f64 group photographer G. Paul Bishop, who used idiosyncratic lighting and posing. Everyone had to be posed in a way that suited them. This is how Eliot got into weddings. 'I found that weddings were a great way to do portraits and I really enjoyed them... although I never made any money at it until I got a mentor who explained how to price things up and how to shoot.'

Eliot's entry into the world of new technology is hardly surprising given his proximity to Silicon Valley in California. Even so, he was ahead of his time in some ways. 'I did a bridal show in 1996 with 100 vendors and I was the only one with a website presence. At that time I used to outsource my scanning, but I got my first scanner in 1998. With this, and before I had a digital camera, I did digital jobs, particularly commercial portraits, and did digital images and was able to charge a premium for simple things like sending a JPEG to someone. I started playing about in Photoshop and I enjoyed retouching images, finding I could improve images before they went onto the website.'

Digital has not really changed Eliot's philosophy on portraiture. 'It's about people being themselves in the picture. I always go for very standard lighting and I never want it to look like I'm using flash.'

EXPOSURE ISSUES
But the key difference with using digital is that there are issues regarding the capturing of exposures. 'It's very important to know you can't always trust the histogram for exposure especially when there are strong colours in the image. That's why I like to shoot with a grey card as it really takes up time and battery power to look at the exposure preview after every shot.'

ACCOUNTING FOR TIME
'If you have a traditional clientele then they want traditional proofs - I give 5x5 images in a box - whereas the new clientele want the bells and whistles.

'The numbers add up OK on the surface in that I can charge 25 per cent more for a Digicraft Album with all the images in, compared with the price for 60 10x10 images in a traditional album, but this doesn't take account of the time factor. Having done film for so many years, I could hire a monkey and tell it how to bag up films and send them to a lab. You can't hire someone casually to do all the back-up and preparation for digital imaging. It's too important.'

FUSSY CLIENTS
'When I got the Canon EOS D30 I had such a good time and it was great fun playing around with risky lighting. In the studio I had it hooked up to the TV and I let the clients look at the images I'd just taken, but my mistake was that I was letting the clients get too fussy.

My sales from digital are fewer and also I currently charge a colour price

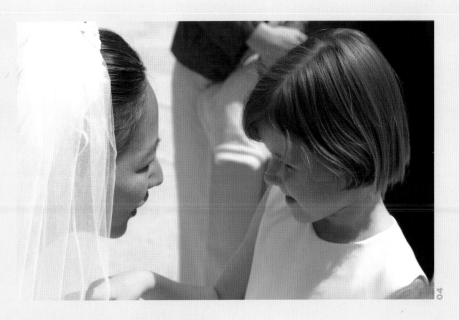

01 Weddings are all about capturing fragments of fun, and the tenderness of the bridal party as they say goodbye to their daughter. Quick shooting allows those to be captured forever.

02 Scene-setting shots will not be hanging on anyone's wall, but they are an essential part of the wedding album, whether traditional or magazine-style.

03 If your clients are intending to have fun on their wedding day, make sure you capture the mood and the mode of the event.

04 As adorable as the bride is, one thing is guaranteed to get the money... managing to capture her talking to an attractive child.

irrespective of the output, which is less than mono work. The jury's still out on the film-to-digital transformation. At the moment my view is that digital allows you to work more and make less money! But it's more fun, and if I could get all my regular work done as well, that would be great. And I have to say that my business has improved in the last two months. The key to success with digital for me is to know how to package it, how to realise what your expenses are and to take a serious look at how digital manipulation and preparation affects my workload.'

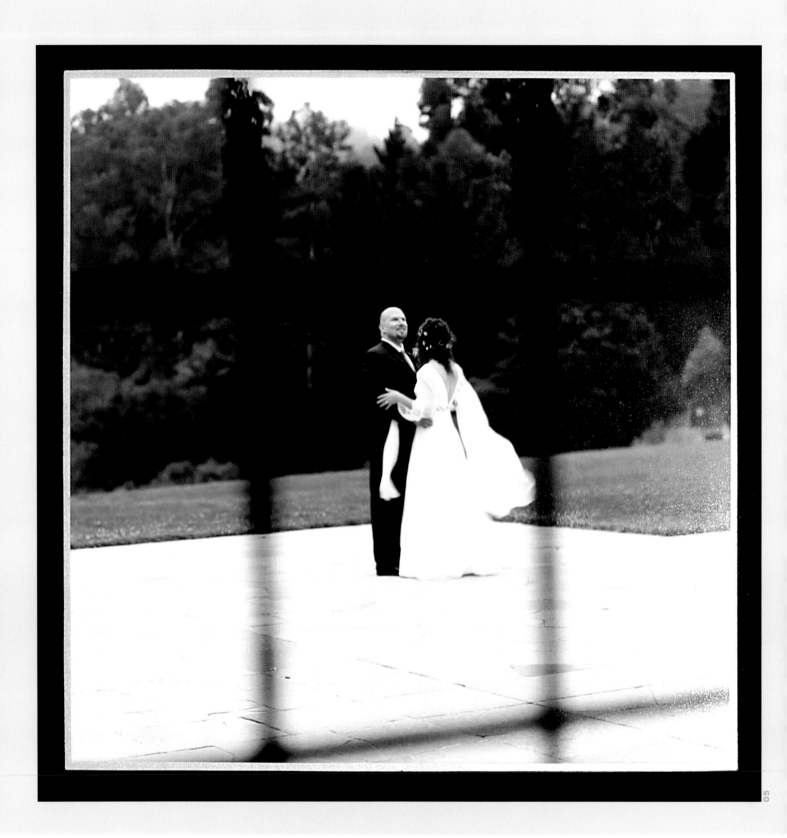

05 Seeing a picture is one thing, being able to capture it in time is another. Luckily, Eliot Khuner's digital basis allows him to do both.

06 Eliot started shooting weddings because it allowed him to take many portraits. Using digital allows him to take considerably more.

07 Even posed pictures, when they are being posed for someone else, can be spontaneous and natural-looking, if you are quick on the draw or can fire away to get the best possible expressions.

MANAGING TIME

IF YOU ARE THE KEY PERSON WHEN IT COMES TO TAKING THE PICTURES AND SORTING OUT THE SALES AND MARKETING OF YOUR PHOTOGRAPHY THEN YOU HAVE LIMITED TIME. SO WHICH PARTS OF DIGITAL IMAGING CAN BE CONTRACTED OUT?

PRINTING

The main candidate for outside help is producing output. This is for reasons of capital cost, running costs and time. You might well be able to output images from your desktop, but it takes time to calibrate output properly. You can get printers that produce better-quality prints in shorter amounts of time, but both the printer and its media will cost more to buy. If you decide to go down the output-to-photographic-paper route, then the only sensible option is to outsource the output.

Few professional photographers have their own lab because unless it is a busy studio, your capital investment and staff are idle. Calculating the cost of printing images in-house is difficult because as well as the financial side, quality control and printing demands represent periods when you are not generating revenue.

It does take time to get your lab to be colour calibrated, but that is part of the conversion process, and a good digital lab is the same as a good film lab. They'll make changes when changes are needed and not otherwise.

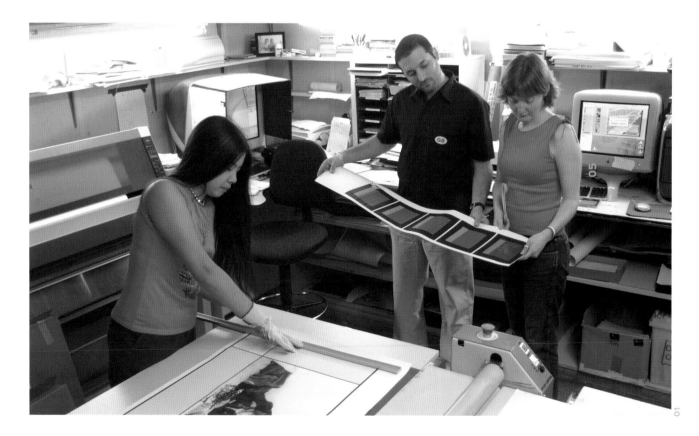

MAINTAINING WEBSITES

There are plenty of people who can design, host, and update a website for you. If you are going to be looking at driving sales through secure connections on the web, this is a job for experts. You can do it yourself, but it is not initially going to be a profit centre. If your website attracts or converts leads to customers, then it is doing its job. If you do start to get print sales, great. But will that level of revenue be worth another job per week? If not, think very carefully about how much constructing a website is costing your business.

If clients want to see their pictures on the web (or want their friends and family to be able to do so) then they should be happy to pay for the privilege. Find out how much your web-hosting company is charging you to add each wedding or portrait session page, and factor that into the quote you give for the wedding. The added benefit of this is that if the clients are paying for the service, you can be much more confident that they will be driving people to use it.

SCANNING

High-resolution scanning is a tedious activity, yet it also needs to be done with care to avoid having to spend time later spotting and touching up. Unless you are really confident that you and your scanner are up to it, get someone else to do it. The lab that processes the film is an ideal candidate for this job. If you can get a batch-scanning scanner (i.e. one that can do a whole roll of film) and you have it calibrated properly, then it can be done in-house, but high-resolution scanning is not 'plug and play'. Anyone who says different is trying to sell you something.

Pro lab
The price difference between digital and equivalent hand prints is why Kevin Wilson uses the PhoenixImaging.com professional digital laboratory.

Web print service
There are more and more remote (or web) printing services. High street labs, wholesale labs, and of course professional labs with the right equipment can all now offer digital printing onto photographic paper.

Don't overreach

ALTHOUGH THE PROSPECT OF LEARNING A NEW TECHNOLOGY HAS DETERRED MANY FROM EVEN CONSIDERING DIGITAL IMAGING, THE REWARDS ARE THERE IN RETURN FOR A PLANNED APPROACH.

Digital imaging is a monster in terms of learning. Lots of people will tell you they've never had any training in it and, with lots of people, it shows. Although most of the photographers featured in this book started from scratch, they now have some experience behind them. They have made their mistakes and have learned from them.

How do you implement a new technology at the same time as running a business? How do you plan a learning curve? There are three things you need to take into account: time, cost and quality. But the fundamental element is deciding what you want to do and breaking it down into easy stages. Ask the right questions, and the amount you need to learn can be significantly reduced.

THE PLAN
The first thing you need to know is exactly how you want to move your business into the digital arena, and how much of it. The second is when you want to do it. The third is to decide whether this can be done in parallel with existing photographic practice in your work. Finally, you decide who needs to learn what within your organisation, and when.

COMPUTERPHOBIA
One of the mantras of technical journalists who have anything to do with photography is that automatic is not the same as automatically correct. Starting from this premise, there is no way you can get involved in digital imaging without knowing something about the way computers work. You could get someone else to do the tough stuff, but if it's not a family member but an employee, you will probably be better off knowing a little so that you know what it is you are asking them to do. In short, it's time to get to know and love the computer.

You need to know how to copy, store, open and perform some basic manipulations on image files. It is also a good idea if you have some comprehension as to what image size and resolution mean. Wherever there are clients, there are questions. It's never a good idea to say 'I haven't the foggiest how it works, but it always seems to come out OK' when trying to reassure clients.

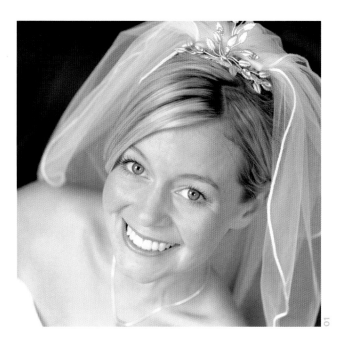

01 In the initial stage of learning digital imaging, there are few more useful pieces of advice than 'keep it simple'. Learn how to do a few things, but learn them well. Applying a mild tone to a greyscale picture is a very effective technique (as shown in this Stuart Bebb shot) but is also quick and easy to perform.

TESTING CAMERAS
You will need to perform tests on digital cameras, not so that you can tell which is best, but to reassure yourself about what it can and cannot do. Can you afford to push the equivalent film speed to ISO 1600 if need be? Perform a few tests and come to your own conclusions.

OUTPUT
Whether you print to inkjet, thermal dye-sublimation printer or get someone else to print to traditional photo paper, you need to calibrate your system (camera, monitor, imaging program, output profile) so that people appear as they should. Skin tones in particular can easily become too magenta, and no client will thank you for making them look like an alcoholic.

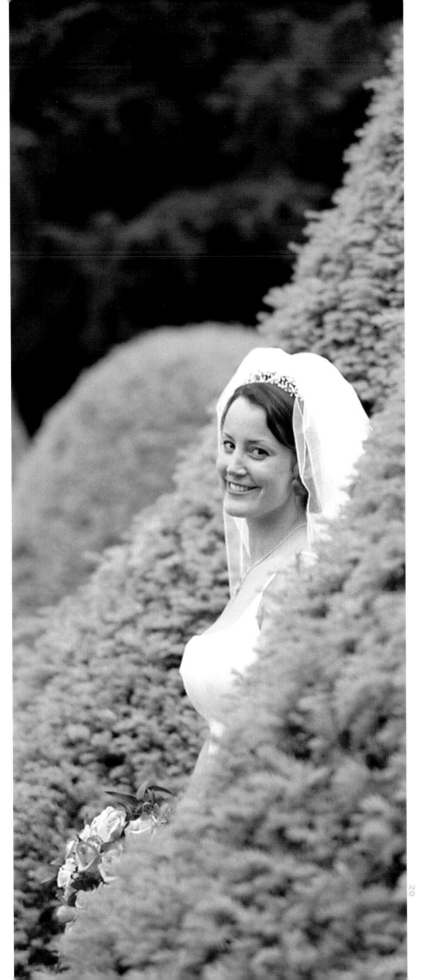

02 Digital image manipulation can be as simple as merely changing the shape of the picture. The great thing with digital imaging is that once the image is in the digital arena, you can try all sorts of different crops on-screen before being committed to how the image will finally look. This Stuart Bebb shot shows how effective a simple vertical crop can be when applied to the right composition.

Time, budget, quality, specification

YOU PROBABLY ENJOY THE PROCESS OF TAKING
PHOTOGRAPHS, AND THE IDEA OF HAVING TO EMPLOY
BUSINESS PRINCIPLES MAY PRODUCE A FEELING OF GLOOM.
BUT THEY ARE NECESSARY, WORTHWHILE AND MAY
EVENTUALLY LEAVE YOU MORE TIME FOR PHOTOGRAPHY.

Computers are very clever. They can also be great fun and can
even become addictive. Digital imaging in the context of your
business is just that, a business, and you need to apply business
principles to the new technology before you get sucked into
spending hours playing around in Photoshop thinking that you
are working.

Ask a management consultant and they will tell you that
there are four key elements to any job: time, budget, quality and
specification.

You can increase the specification and quality of a job, but it
is likely to cause an increase in the budget and probably the time
required to do the job. As you are working for yourself, increased
budget comes out of your pocket and increased time comes out
of your life. It's well worth applying these four criteria to the
implementation of any new item in your business and employ
a little self-negotiation.

TIME
If it takes you twice as long as an outside lab to provide the same
quality you are wasting money. You might think it's cheaper doing
it yourself, but have you factored your lost earnings per hour into
the equation? And when we talk in terms of time we are talking
about the actual amount of time it takes to do a job, not the gap
between deciding to do it, and when it is finished. Next day is
virtually always quick enough. Next week is very often quick
enough. So even if you can do something in two hours, you need
to ask whether there is the need for it.

BUDGET
You have already quoted for the job you are shooting. In the case
of weddings you may have quoted before going digital, and any
extra costs you introduce to a job by going digital come straight
off the bottom line. The more time and money you spend on

doing a job digitally, the closer you get to actually losing money on a job. You can call some jobs 'training', but you can only do that for a very limited period before you start working harder for less money.

QUALITY

The idea of digital imaging is to offer as high or higher quality to the client. Do not give out failed prints as proofs. Instead, leave them to one side to be used for training purposes. Do not show potential clients failed prints. Only show high-quality final proofs. Remember, very many clients will also have inkjet printers at home, and indeed may be more expert in producing simple prints than you initially are. Producing anything less, or even only as good as they themselves can produce, is going to make them think you are overcharging them.

SPECIFICATION

Digital offers many possibilities, some that cannot be emulated by traditional photography. However, there is nothing that says that you need to exceed clients' expectations in terms of what they have asked for. You may have offered them the choice of fifty pictures when they booked, so giving them 500 won't make it easier for them nor necessarily increase your sales - only your workload.

For each aspect of the digital imaging chain, it is worth asking yourself which method of implementation - doing it in-house or getting an external company to do it - will best fulfil the criteria laid out above. It is surprising how hard it is to justify doing things yourself once you've examined the relevant criteria. There's nothing wrong with that, it's just the easiest way of learning that what you do is photography. Everything else can be a distraction.

01 There is certainly quite a lot to get excited about with digital, but like this Ian Cartwright picture, it is a question of getting everything in the right place at the right time.

A little learning

IT'S IMPORTANT TO INVEST TIME IN EXPANDING YOUR KNOWLEDGE OF THE PROCESSES, BOTH CENTRAL AND PERIPHERAL, OF DIGITAL IMAGING. KNOWLEDGE MEANS CONTROL, AS WELL AS POWER.

01-04 All the pictures this page are by Richard Lemon. He found that the reduced processing costs after switching to digital amounted to a saving of £5 per client.

Anyone who has heard a tradesman sucking air through his teeth while presenting you with an invoice for £500 will understand the importance of knowing what someone else is talking about. If someone tells you 'Your grommet flange viscosity regulator's packed in, I need to install a whole new cross-widget assembly', it's satisfying to be able to say, 'No, it just needs a new washer'.

Hopefully, you won't have people trying to make money out of you like that, but knowing your subject reduces ambiguity, tells you what's possible and allows you to maximise the efficiency of your in-house and out-sourced resources.

Digital imaging involves a lot of new disciplines – the proofing is different, the archiving is different. You must find a system for storing images safely, at original resolutions as well as in colour corrected form, and yet be able to retrieve them extremely quickly. Collaborate with the person doing the correction and archive work to plan the system between you, and adhere to it.

KNOW WHAT IS POSSIBLE

If you are going to ask an external contractor or internal employee to do something, you need to be convinced that it can be done. Only by using tests to learn what is possible can you then ask someone else to do it for you. If you are using Adobe Photoshop, you can set up actions (series of instructions) that could, for example, be used to append a part of a filename to a file. An action could also be written to save two different versions (colour and sepia-toned mono) of each file. You can apply actions to batches of photos so that they can all be processed overnight or while you are away from the computer. When the process is controlled like this, it becomes quicker. However, colour correction needs to be done on a picture-by-picture basis, unless you expose and set colour correction with a grey card for every picture.

ITEMISING COSTS

Another issue of concern is how much you are being charged for digital work carried out away from your premises. Again, knowledge of what is involved will help. If you are using an outside printer, get them to show you exactly what they do for your money. The more you know about what they do, the better you will be able to negotiate with them over what you want. You could also reciprocate and invite people to examine your set-up so they can have some ownership of any colour-calibration questions that need resolving. If you are going to offer a lab an exclusive contract to print all your images, they should certainly help in ensuring the highest possible quality.

01

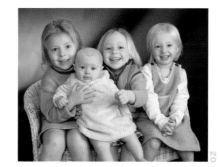

02

03

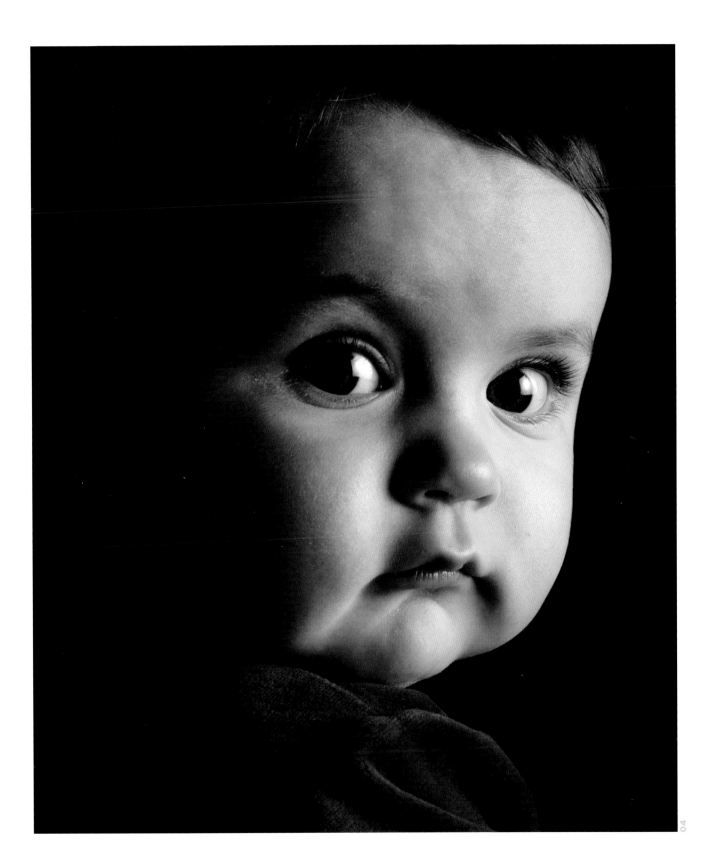

04

STUART BEBB
'Even the brides' mothers are going for reportage'

01

Stuart Bebb has been a professional photographer for 22 years, but his business developed in a highly unusual way. 'I have two photographic jobs: I'm a photographer for the Department of Physics at Oxford University and I'm also a wedding photographer with my wife, Jan.'

'My photo education was at Blackpool college where I met Roy Doorbar, who was part-time lecturer in portraiture. It was through him that I got involved with wedding photography. The business has grown organically over the years – the wedding business growing alongside the physics work. I shoot about 30 to 35 weddings a year. It used to be seasonal, but over the last four or five years it has spread across the year into the winter months. Winter weddings are just horrible – clients don't take into account how little daylight there is.'

PHOTOSHOP FOR DESIGN
'What the physics job did do for me was introduce me to digital. It was a natural progression to what people in the department required, that they could import into whichever presentations they were doing. Initially, about five years ago, this was in the form of scanning. Almost immediately I saw that I could use this in weddings. Of course, once you start getting into Photoshop, you start playing with filters... I spent a lot of time wasting time with the filters in Photoshop although I don't do it a lot now.

Photoshop is a huge program and I use it primarily in a design sense for the creation of albums as much as image improvement, which these days only takes the form of tweaks.

'I started creating the albums in Photoshop after going to Wedding and Portrait Photographers International (WPPI) in Las Vegas and saw what people – especially Australian photographers – were doing. There was some really innovative stuff with albums.'

REPORTAGE
After the album concept's journey over the Pacific, Stuart brought it back across the Atlantic, and with good results. 'We're getting a very good response from people in terms of the digital album. Not everyone is like that, but there has been a definite shift in style required. The reaction is, "Can we have the reportage instead of the traditional album?" We just don't do any posed traditional albums anymore. Even the brides' mothers are going for reportage.

'The way we present our photo-graphs now has changed as we don't

provide the bride and groom with pre-view albums. The images are scanned and then printed four-up on an A4 page with 75 pages for 300 wedding images.'

As far as web presence is concerned, Stuart has a website, but it is for marketing and information purposes only at present. 'We did look into online ordering, but time constraints have precluded our going down that road at the moment.'

SCANNING IN BULK
Stuart still uses film for all his actual photography, but uses the power of scanning to get his images into the digital domain. 'We use a bulk scanning Nikon Coolscan4000 so we can load it up with a film and walk away while it scans and saves the images. We do nine or ten films per wedding.'

The question arises: has this switch to film and scanning improved Stuart's business? 'Absolutely. For example, by using the Permajet Inkflow system, and with the inkjet paper we use being relatively inexpensive, we just get the films processed – we don't get them printed anymore.'

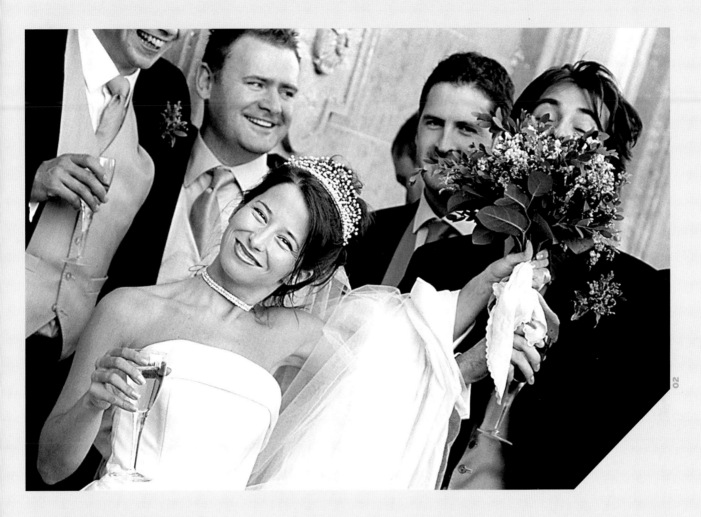

01 Straddling the unlikely worlds of pure physics and wedding photography, Stuart Bebb is uniquely placed to know that digital photography delivers the goods.

02 Stuart Bebb uses a different system from the other photographers in this book, as he uses a hybrid silver halide and digital system. But a key is still the use of an easily portable SLR, which allows a greater number of shots per film than a medium-format camera.

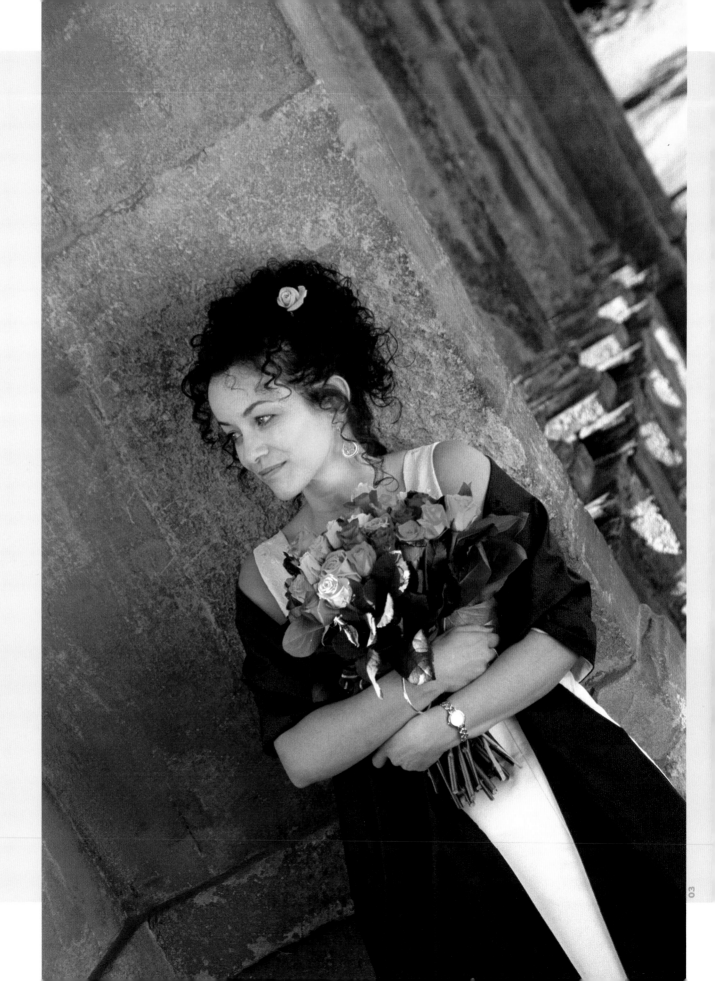

REORDERS

As well as cost savings, how has the switch to digital affected Stuart in the area of sales? 'The real soul-searching [when I was thinking of going digital] was over the wedding reorders from albums. They were pretty good with the traditional method, and I thought I'll give it twelve months to see if the reorder values hold up. If anything, reorders have actually increased. To give an example, about a month ago I shot a very small wedding with just twenty guests, which I did for an attendance fee, and the re-orders came back at over twice the fee for the wedding.'

Why is this? 'We always ask people whether they find it [the digital album] acceptable compared with traditional. So far we've got a 100 per cent approval rate.' You can't argue with that figure.

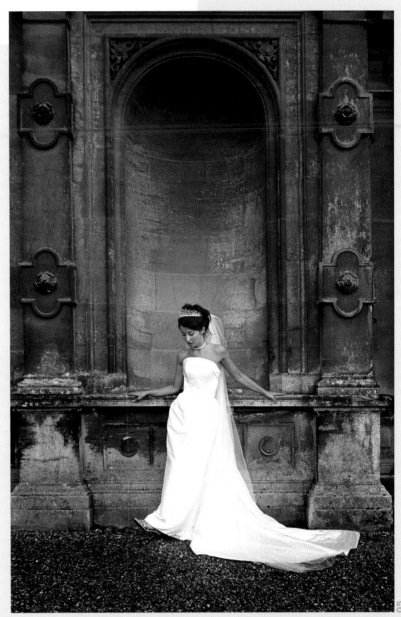

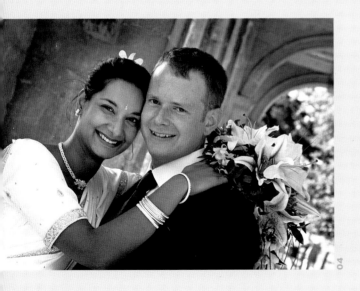

03 Although Stuart shoots on film, he can still use the control (whether as simple as dust spotting or creative manipulation) that the digital element allows.

04 & **05** Sympathetic toning is one of the great advantages of digital manipulation and output. Results can be previewed and minutely adjusted to get exactly the effect required in a wide variety of hues.

IAN CARTWRIGHT
'Concentrate on the creative aspects'

For fifteen years, Ian Cartwright and his partner Brian Spranklen have been among the most successful commercial photographers in the business. They have worked on campaigns for some of the biggest brands and have won many awards.

Despite this apparent success, the pair found that when commercial photography's peaks and troughs were evened out, they weren't averaging much more than a teacher's salary. On the other hand, the best social photographers were doing far better.

BUSINESS FRANCHISE
In the year 2001 Ian Cartwright won the British Institute of Professional Photography's Portrait Photographer of the Year award, and Ian and Brian joined with their stylist, Barbara Taylor-Jones, and branched out into a new business as Venture social photography franchisees. Venture is a brand that aims to bring the highest-quality portraiture and customer service to high streets everywhere, without concentrating on individual names. It's not just a sign above the

shop front, though: Venture has developed a complete business model, including marketing expertise, training and managerial backup. Another big advantage is that this type of business can be sold on when the owners decide to retire, rather than being worth nothing because clients have been buying your individual service.

NEW PLACE, NEW CAMERAS
In January 2002 the partners moved from a large commercial studio in a Manchester back street to a shop located on the busy A6 main road in Stockport. Here they can still accept the cream of commercial photography, while building their new Venture portraiture business.

The move to Stockport and to the Venture franchise was also a time for another change: a move to digital

capture. Cartwright's portrait studio is an infinity white set, where the emphasis can be all on capturing the human face and form and the spontaneity of expressions and the right moment. He chose the Kodak DCS760 digital camera, with a true six-megapixel sensor and fast response time.

Client previews are carried out using a digital data projector, which projects images onto a large screen. Image files are uploaded from the camera into a PC, where stylish multi-exposure and other effects are added. The finished image files are then sent to Venture's centralised laboratory, said to be the biggest and most advanced in Europe, for printing and framing. This allows Ian Cartwright to concentrate on the creative aspects of capturing pictures that his clients love.

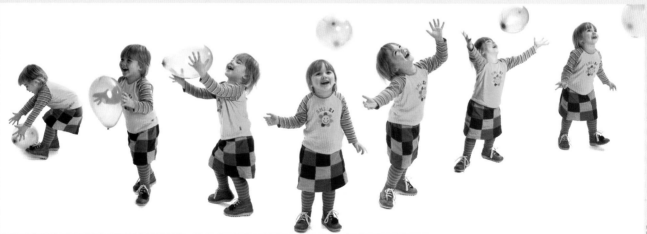

01 Ian Cartwright and his Kodak digital SLR.

02 One of Ian's classic multiple shot compositions. Careful control of studio lighting is essential for a shot of this type.

03 High key shots are achievable with digital SLRs, but it is important never to overexpose or all detail will be lost before any other manipulations can be performed.

04 Clear windows, huge sample shots and an inviting interior contribute to the attraction of Ian and Brian's new high street venture.

06 & **07** As with any discipline in photography, digital studio portraiture is all about the control of light and shadows. Ian's studio has an excellent set-up that makes the most of the image recording ability of the Kodak DCS 760.

08 Light control is not all about blasting out shadows, it is about sensitive control of contrast too. In this shot, the wraparound lighting has allowed an appropriately soft effect to be captured, and this is enhanced by the low-contrast monochrome output.

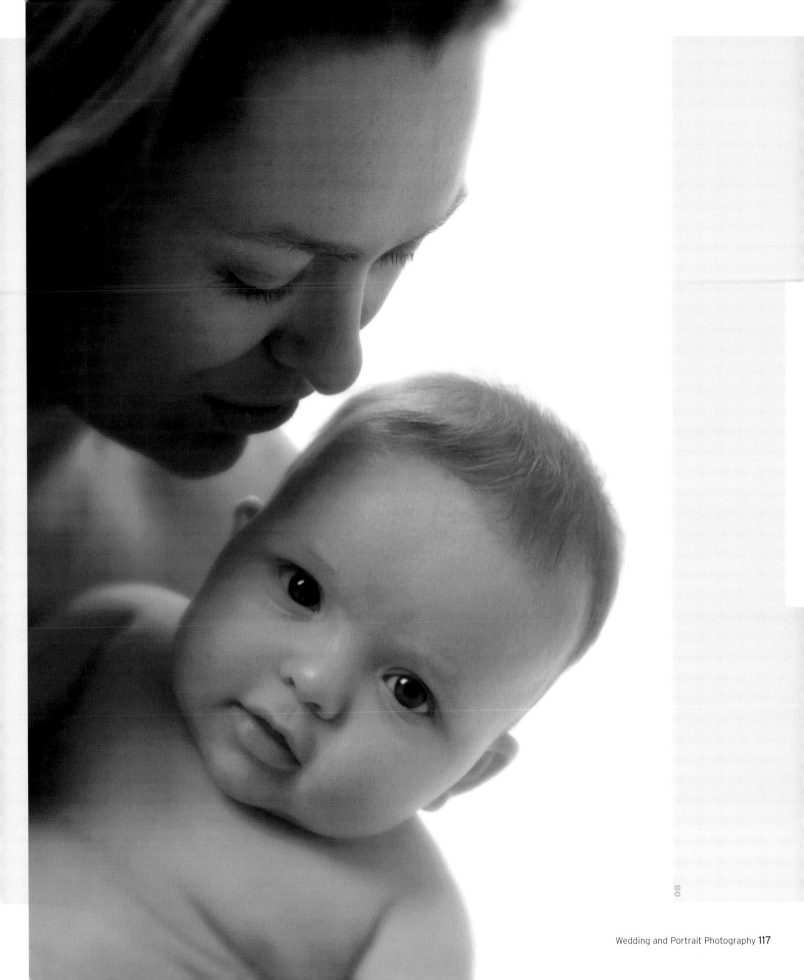

USEFUL INFORMATION

BOOKS

There are many books available on how to use Adobe Photoshop in particular or digital imaging in general. There are, for example, 70 books containing the words 'digital imaging' on Amazon.co.uk and a staggering 133 relating to Adobe Photoshop. On Amazon.com the equivalent figures are 399 and 280!

Some are more useful than others and it is well worth checking through a book (or if you do want to order online, check out the reviews) before deciding which one to plump for.

There is also the **Complete Guide to Digital Imaging** (by co-author Joël Lacey with contributions from Phil Andrews and Peter Cope) for a thorough overview of digital imaging in all its forms, and some basic skills-learning sections on Photoshop. But for more specific titles, there are a few authors with an excellent pedigree in the field. Names to watch out for in particular in the UK are Phil Andrews, Martin Evening, Peter Cope and Simon Joinson. The best US writers are Katrin Eismann and Deke McClelland.

Probably the best book to get you started is Phil Andrews' **Adobe Photoshop Elements** (which focuses on the cheaper incarnation of Photoshop)

but which gives easy-to-follow examples of the different kinds of manipulation you will be doing on images, from retouching scanned images to colour corrections, sharpening and blurring and outputting.

If you want a heavier read in all senses of the phrase, there is Martin Evening's **Adobe Photoshop for Photographers**. This should communicate the intricacies of digital imaging in a language familiar to photographers.

For very useful tricks of the trade for the more advanced practitioner there is Steve Caplin's **How to Cheat in Photoshop**. Although primarily a book on the more advanced techniques you can use in creating montages, there is a truck-full of tips that alone make the book worth buying.

When choosing which title to go for, examine what your own requirements are. Which section of digital imaging do you need tutoring in? Digital cameras, scanning, image manipulation, image correction, preparation for output? Decide where your weak points are and then choose a book that best suits your needs. Books with illustrated step-by-step 'how to' sections are useful,

but make sure the subjects that they are covering are relevant to what you want, otherwise you will just spend time whiling away the hours in Photoshop – and you can do that without paying someone for the privilege.

Look at the glossary and jargon-busting sections, and also see how they are organised. Some people prefer the alphabetised listing of terms, others prefer to see them arranged according to categories. Both are equally useful, but you may want to get hold of one of the number of alphabetised guides to use as a ready-reference alongside a more complicated book.

For further information on websites, Phil Andrews' **The Photographers' Website Manual** shows how to improve any photographic business that uses the web. It covers building or improving websites, ensuring traffic is driven to your site, ensuring your images are well-presented online and covers income generation from the site. Tried-and-tested techniques are used throughout and there are useful case studies. This is a practical guide showing how to maximise the web's potential as a business resource. It's published in January 2003.

ONLINE INFORMATION

There is obviously no shortage of websites about digital imaging on the internet. Some, it must be said, are significantly better than others. Three that stand out for clarity, depth and above all accuracy of information are the following.

For a visual introduction into how digital imaging works, go to **www. epi-centre.com/basics/basics1.html**. This site (by co-author John Henshall) will guide you through the basics and then take in some of the more important issues on the next level.

For a structured look at various aspects of digital imaging, albeit from a home-user's point of view, there is Agfa's digital photography course (an 11-part course) that you can find at **www. agfanet.com/en/cafe/photocourse/ digicourse/cont_index.php3**. This covers a brief history of digital and electronic imaging, then has sections on how digital cameras and scanners work. For a more specifically Photoshop-oriented learning centre, there is **www.photocollege.co.uk** and more specifically its digital learning zone. Authors Tim Daly and Phil Andrews cover some of the material in the websites above, but also give some

excellent tips for Photoshop usage including speeding the program up (well worth looking at) allocation of memory and scratch disk usage, and a visual guide to tasks that will become everyday ones, like using levels and what all the sliders do.

There's even a separate section on the more creative uses of Photoshop, along with very useful downloadable actions and filters for applying very different effects to your colour shots.

Another site, **www.users.qwest.net/ ~rnclark/scandetail.htm**, is the most complete description of the issues of resolution in digital cameras and scanning available on the internet. It debunks some of the fallacies of digital imaging. You will also find the answer as to how much resolution is needed in order to capture all the detail from a film original. However, if the question is whether you will need all of this information to help in the day-to-day use of digital imaging, then for the most part the answer is 'no'.

DOZENS OF BITS

"But wait a minute, what's this I keep hearing about 'twenty four bits'?"

Twenty four bits come about because eight bits are required to describe each of the primary colours -- red, green and blue -- which combine to make a colour image. Three times eight is twenty four.

If your brain is not hurting too much already, the number of combinations of any one of 256 levels of red, together with any one of 256 levels of green, together with 256 levels of blue is 256 x 256 x 256. That comes to a staggering total of 16,777,216 colours. Don't worry about being challenged to name them all, it's easy: red, green and blue - the other 16,777,213 are simply a matter of proportion.

So there we are. That's why you need 'twenty four bit colour' on your monitor to display photo-realistic digital images in full colour.

A BIT TOO FAR

I've also heard mention of 48 bit colour, what's that?"

... Steady on, now - a bit at a time please.

01 & **02** Co-author John Henshall's company website **www.epi-centre.com** gives a good grounding in the essentials of digital imaging.

03 www.photocollege.co.uk is a very useful internet resource for information and guidance on Adobe Photoshop usage.

04 Digital camera and scanner manufacturer Agfa has an online 11-part course in digital imaging at its Agfanet portal.

ELECTRONIC PHOTO-IMAGING
at the EPIcentre
The Art & Science of Digital Imaging

THE ANALYSIS OF COLOUR

Equal amounts of red and green make yellow, equal green and blue make cyan, and equal red and blue make magenta. Equal amounts of red, green and blue light mix to make white light.

A red rose with green leaves set against a blue sky, has all the natural primary colours.

The camera analyses the image into separate red, green and blue signals which are passed to the computer. One channel represents the red component, another the green, another the blue. The computer monitor converts each of the channels back into red, green and blue light at the face of a cathode ray tube. The three primaries are 'mixed' in our brains to reproduce the full colour image.

The inside of a monitor's cathode ray tube is black until the electron beams, driven towards the screen, excite the phosphors to emit light. The phosphors can only glow either red, green or blue. White is made up of equally bright red, green and blue adjacent dots (or slots) in the screen, other colours being made up by having adjacent colours glow in varying proportions. This is a kind of additive colour mixing where the 'mixing' is done in our brains. The dots of phosphor are so small - less than five thousandths of an inch in diameter - and so close together that, at normal viewing distance, they appear to merge. Take a magnifying glass to your television or computer screen now and you'll get the picture in a big way.

The greatly enlarged detail shows the structure of a shadow mask colour monitor tube, made up of individual phosphor dots, each less than five thousandths of an inch in diameter. At normal viewing distances these dots appear to merge. The dots shown here are all glowing equally brightly and would 'add up' to make white on the screen.

Photoshop Tutorials

GLOSSARY

Adobe Photoshop The image manipulation program that allows you to view, edit and creatively manipulate digital images. A less comprehensive version of the program (but costing only 10% of the price of the full Photoshop) is Adobe Photoshop Elements.

A/D conversion Conversion of an analogue signal (voltage) to binary digits (0s and 1s). The greater the number of bits used to describe the analogue signal, the more accurate it will be.

Apple Manufacturer of the Macintosh hardware and operating system.

Bicubic An interpolation method. Interpolation involves adding or deleting pixels by sizing an image up or down. Somewhere there has to be guesswork and bicubic interpolation looks at all the existing surrounding pixels in an image before making a change.

Blurring see Gaussian blur

Calibration (Colour) see Colour management

CCD (Charge-Coupled Device) The array of light-sensitive square receptors used to pick up the image in a digital camera or scanner.

CD-ROM Recordable disc with a capacity of 650Mb or 700Mb.

CMYK Cyan **M**agenta **Y**ellow and blac**K** – the default colour mode for offset-litho printing use. Should not be used for photographic images to be output to photo paper.

Colour management The process of making sure that what you see is what you get. The blackest of the black arts in digital imaging.

Colour mode You could be making web pages; you could be making a brochure to be printed; you could be displaying images or copying them from one computer system to another. Some devices and computers have a very limited understanding of colour; some need certain colour models in order to work properly. When you change colour mode you adapt the model you are using to a more appropriate one.

CRT Cathode Ray Tube – the system on which all TVs and monitors except TFT and LCD systems are based. Fires electrons at tri-colour phosphors to create a colour image.

Digital Anything existing in the form of binary digits – 0s and 1s. Binary digits are grouped together in bytes of information.

Digital camera A camera that doesn't use film but an array of light-sensitive cells to capture an image. The resolution of the image depends on the size of the array, while the quality depends on how many bits of information the chip inside the camera can cope with.

Digital output This is a bit of a misnomer as the only true digital output is as a saved file. All printer output and CRT screens are effectively analogue

Dodge Like the same term in printing, a dodge tool allows you to brush over areas of an image to gradually make those areas lighter.

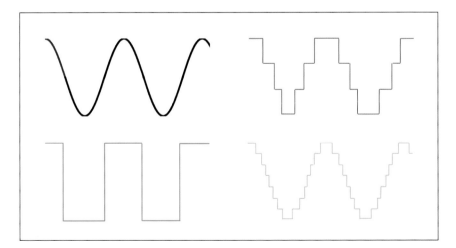

A/D conversion
The black wave represents an analogue signal. The red, blue and green shapes are respectively 1-, 2- and 3-bit digital translations of that signal. An 8-bit translation (with 255 steps) would be indistinguishable from the analogue signal at this size and a 16-bit translation indistinguishable at any size.

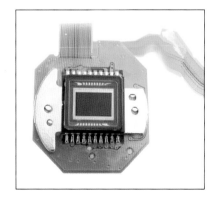

CCD
The heart of a digital camera is its CCD (Charge-Coupled Device). This turns the light falling on the sensor into analogue signals that are then converted to 0s and 1s (see A/D conversion).

DPI Dots per inch. The number of dots to the inch at which you ask your printer to reproduce an image. Not to be confused with pixels per inch (ppi), which is used for describing digital image resolution in the computer or at the scanning stage.

Duotone You can get better results when you reproduce black and whites with two colours of ink. You can do this for effect, reproducing sepia pictures by including a large amount of the second colour, or you can do this to subtly enhance the final printed picture. Quadtones use four colours and Tritones three. Sometimes you can use these to create other picture-qualities, such as coloured solarisation or poster effects.

Dye sublimation (thermal). Method of printing using coloured wax to form images on paper.

Feathering Blurs the edge pixels of a selection in Photoshop or other editing/manipulation program. Useful when applying blurring or sharpening (see Gaussian Blur and Unsharp Mask) to parts of an image so the effect is not too obvious.

Filter Generic name for a whole host of different effects available in Adobe Photoshop.

Firewire A very quick peripheral connection system. Competes with USB 2.0.

Gamma A monitor's gamma is determined by how light and dark it displays. Getting your monitor properly calibrated (using Adobe's Gamma control panel) is the first step to correct colour calibration of your digital system.

Gaussian blur A method of applying an impression of defocus to an entire image or part of an image.

Greyscale or Grayscale The mode used for recreating black and white photographic images and smooth black and white blends.

Healing brush Photoshop tool useful in restoration work and used to remove annoying distractions against blurry backgrounds.

Histogram Shows in graphical terms (a horizontal array of vertical bar charts) the amount of each particular shade of grey across the range from white to black. Can sometimes be misleading when faced with a big block of colour.

Inkjet Printing system that fires tiny drops of coloured and/or black inks at a sheet of paper.

Interpolation see Bicubic

Colour
A 'straight print' of the digitally captured colour image.

Duotone
A combination blue/sepia tone applied by tweaking the Blue Curve in the Curves section of Photoshop.

Sepia tone
This tone was achieved by applying a spot colour to mix in with the black in the Duotones command of Photoshop.

JPEG (Joint Photographic Experts Group) A picture compression system used in digital cameras to keep file sizes manageable. Picture files can be huge, so applying compression can make a lot of sense. JPEG does cause loss of information, however, and should be used with this in mind.

Lasso A tool for making an irregular (i.e. not rectangular, circular or ovoid) selection on an image (see also Feathering).

Lossless/Lossy Refers to compression methods they describe. Respectively: where no image information is lost, and where some (or indeed a lot) of image data is lost in the compression process.

Megapixel Measurement unit loosely describing the number of pixels in a camera's CCD. A CCD with one megapixel resolution actually has 1,048,576 effective (i.e. image forming) pixels on it.

Nyquist frequency The factor by which the resolution of a subject to be scanned or photographed needs to be exceeded by the capture resolution in order for all of its detail to be recorded.

Pictrostat/Pictography Proprietary Fuji system of printing photo-realistic images in an environmentally friendly way.

Pixel Picture element. A tiny square block of colour. When you scan a picture you can specify how many of these you want to the inch (pixels per inch - ppi). This will be the resolution of your image. The resolution of an image defines its quality – line art is high resolution, often over 2000 ppi. Reproducing photographs to professional quality would mean scanning at around 300ppi. Monitors typically display at 72ppi; this has nothing to do with the actual resolution of your scan, though it does mean that something that has a resolution of 300ppi will appear to be much larger on the screen than it actually is.

Pixellation Where an image appears blocky and the pixels are visible. Normally happens when an image is printed with a resolution of under 150ppi.

PPI see Pixel

PSD Default Photoshop file format. Use either this or a TIFF format when saving back-up copies of images as you work on them. PSD is compression-free and also allows layers to be saved in it.

RAM Random Access Memory. Temporary memory inside your PC. The more your computer has, the better. Many graphics packages, such as Photoshop, need up to four or five times as much RAM as the size of the files you're working on to process images properly.

Resolution How many pixels per inch an image has.

Gaussian blur
One of Photoshop's most useful filters, it allows a selected area to have distracting detail de-emphasised by blurring it until it is no longer intrusive.

Healing brush
A new Photoshop tool that makes the restoration of images much simpler and quicker, as this before and after set shows.

Restoration The process of electronically cleaning up and repairing old images. Much aided by Photoshop 7's healing brush tool. Restoration can be either a useful sideline business, or a great drain on your resources, depending on how much you charge and who does the work.

RGB Red Green Blue. The default colour mode for image processing.

Saturation Take a colour and slide the saturation bar to 0% and that colour will turn grey. Any point between grey and the pure colour describes its level of saturation.

Scanners These devices allow users to capture images from reflective (paper-based) and transparent (film-based) originals. A scanner will probably use CCD technology (see CCD). There are two basic types: flatbed scanners and transparency scanners. The flatbed is also known as a print scanner and the transparency also known as a film scanner. Some film scanners allow whole films to be scanned in at once.

TIFF Picture files that can be swapped between a large number of programs. TIFFs are one of the preferred file formats for layouts that are going to be printed. TIFFs can also be compressed using LZW compression when saving them. Unlike JPEG, LZW compression doesn't lose any data.

Unsharp Mask (USM) There is sometimes lack of bite in scanned images due to the deficiencies of the scanner, or merely because the resolution isn't high enough to capture all the detail. Unsharp masking is a way of making the edges within an image sharper again, thereby restoring the image to look more like the original. Using USM too much results in detail being lost and a spiky jaggy look. USM may already have been applied by a digital camera or scanner at the capture stage, so it may not always be necessary.

USB A connection standard that has effectively replaced serial and parallel ports on PCs, and ADB serial and SCSI ports on Macs for using with devices such as scanners and printers.

USB 2.0 As its name suggests, this is a newer version of USB that allows the transmission of data from devices such as scanners much more quickly.

No Unsharp Mask
Detail is slightly soft.

Unsharp Mask applied
Image looks sharper.

Unsharp Mask reapplied
Detail is now being lost due to contrast.

INDEX

Acknowledgements

The authors would like to thank the photographers whose work appears in this book, the staff at Design Revolution, in particular, Becky and John for their hard work and dedication, Nigel Atherton and the staff at RotoVision for making this book come together.

Joël Lacey and John Henshall